BRITAIN'S HERITA

YORKSHIRE'S VIKING COAST

Joan Ella

IAN D. ROTHERHAM

AMBERLEY

First published 2015

Amberley Publishing
The Hill, Stroud
Gloucestershire, GL5 4EP

www.amberley-books.com

Copyright © Ian D. Rotherham, 2015

The right of Ian D. Rotherham to be identified as the
Author of this work has been asserted in accordance
with the Copyrights, Designs and Patents Act 1988.

ISBN 978 1 4456 1806 7 (print)
ISBN 978 1 4456 1818 0 (ebook)

British Library Cataloguing in Publication Data.
A catalogue record for this book is available from the
British Library.

Typesetting by Amberley Publishing.
Printed in the UK.

Contents

About the Author

Born in Sheffield in 1956, Ian Rotherham is Professor of Environmental Geography and Reader in Tourism & Environmental Change at Sheffield Hallam University. He has written over 400 papers and articles, and numerous books. His research includes landscape history, the economics of landscape change, coastal and moorland ecology, and aspects of tourism and economic development. Ian works extensively with the popular media and with grassroots conservation groups, writes for newspapers such as the *Sheffield Star* and the *Yorkshire Post*, and has a regular phone-in on BBC Radio Sheffield. He has been visiting and researching Yorkshire's coast for over forty years.

Introduction

From the strikingly beautiful cliffs of Bempton and Flamborough Head, Bridlington Bay sweeps southwards to the mobile, sandy promontory that is Spurn Point. Historically the inland area was a vast wetland of fen, marsh, mere and carr, and the higher ground of the Yorkshire Wolds was sheep walk and rabbit warren. Perhaps more than fifty small lakes, or meres, resulting from geological process following the last major glaciation, have gone through a mixture of farming improvement and drainage, and the inexorable effects of the North Sea battering the coastline.

Today the coast, still eroding, is a major seaside holiday destination and a rich wildlife resource, and inland is rich farming country. Centuries of human interaction with nature and landscape have created a rich heritage of old villages, ecclesiastical buildings, castles, great halls and parks, and more recently, nature reserves. Traditionally, the economies of the region were powered by farming and fishing, with trading ports at Bridlington and, in the south, via the major city of Kingston-upon-Hull. Herring fleets, deep-sea cod fishers, whalers, coalers and others have long plied their trades along the Viking Coast. Nowadays, the economy is one of leisure trips by the *Yorkshire Belle* from Bridlington Harbour to view the seabirds at Flamborough and Bempton, and of smaller pleasure boats.

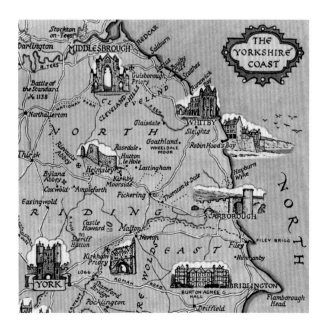

The North Yorkshire Coast.

Prehistoric peoples settled the high ground of Flamborough and Bempton, and the Romans based their shoreline signal stations here. The Holderness landscape presents a rich tapestry of prehistoric and later settlements and archaeology. Early medieval churches dot the countryside and there are major estates and houses from the Norman period through to the eighteenth century, together providing the backdrop for today's tourism industries. Bridlington boasts a surprisingly long and distinguished history, with Old Burlington and Bridlington Quay both harking back many centuries. The magnificent Bridlington priory church, the gatehouse and the monastic ruins bear testimony to a major centre for the management and control of extensive ecclesiastical estates. The monks improved, drained and harvested the landscape to take crops and fish, including eels, and peat turf for fuel, plus withies and other materials for construction. Their footprints are still etched indelibly into the grain of this region. By the ninth and tenth centuries, the coast had been raided, ravaged and settled by the Saxons and then the Vikings, culminating in the 1066 invasion by Harald Hardrada. This remarkable seashore is truly the 'Viking Coast', and the best place to enjoy traditional fish and chips today, undoubtedly, is sitting on Bridlington Harbour.

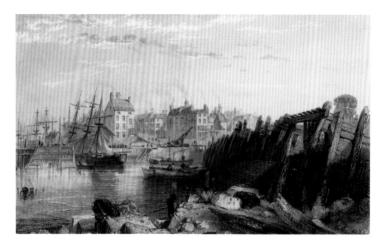

Bridlington Quay, early 1800s.

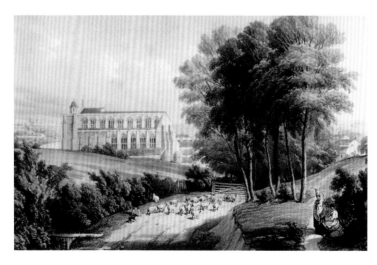

View of Bridlington priory church seen from the south in an early nineteenth-century print.

The History, Landscape, Wildlife & People of the Viking Coast of Holderness

This first chapter sets the scene for the region, covering the unique history, landscape, heritage, and the shrinking shoreline – the most rapidly eroding coast in Europe. It is remarkably rich in wildlife too, and especially in seabirds, with major nature reserves dotted along the seashore, from coastal sand dunes and beaches to dramatic cliffs. Day visitors and holidaymakers still flock to the region, especially when the weather is good, and wildlife enthusiasts such as birdwatchers are there all year round. New developments are seeking to maximise the benefits from wildlife watchers through a network of nature reserves and visitor centres, from Bempton to Flamborough, and from Hornsea Mere to Spurn Head.

A Heritage Coastline

The Holderness coast of the Yorkshire East Riding has rich archaeological resources from Mesolithic sites to Bronze Age burial mounds. Much has been lost to the power of the sea, including extensive Roman signal stations. There are major medieval features such as Skipsea Castle and evidence of agriculture such as farm sites and field systems. Post-medieval sites include several lighthouses, coastguard stations, and remains associated with the fishing industry, though many of these have been swept away. There are numerous military installations, including Second World War defensive works, such as pillboxes and anti-tank blocks made of concrete, and radar stations or airfields from the 1940s and from the Cold War.

Much of this resource is under imminent threat of destruction, so the government agency, English Heritage, commissioned 'The Yorkshire and Lincolnshire Rapid Coastal Zone Assessment' (or RCZA) to assess the situation. The hidden heritage includes sites, features and artefacts on the land itself, but also zones below the low-water mark, including shipwrecks, wreck fastenings, dive sites and dredgings, and anything remaining from the numerous lost villages.

The hamlets and villages of Holderness are a rich and interesting resource, with Saxon and early Norman churches, ancient settlements with stone crosses, and even massive, prehistoric standing stones.

Landscapes of Contrast

The Viking Coast includes areas of dramatic contrast, with the chalk cliffs of Flamborough and Bempton so entirely different from the flatlands, dunes and low clay cliffs enclosing Bridlington Bay. At the southern end of the bay, there are extensive areas of beach on which munitions and unexploded shells can still be found with relative ease. If found, do not touch – and certainly (unlike someone I know) do not load them into the car and drive home. That way lies potential tragedy and misery!

Inland, the flat coastal belt gives way to the gently rolling and undulating farmland of the Yorkshire Wolds, where much of the wildlife and heritage has been farmed away to oblivion; another lost landscape. The affluence of farming from the 1700s to the present day is reflected

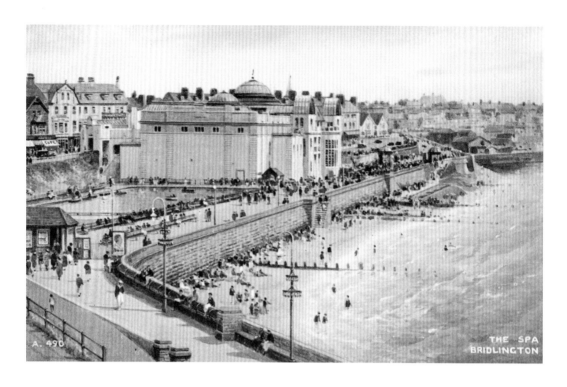

Above: The Spa at Bridlington, 1950s.

Left: Sailing by moonlight on Hornsea Mere, 1971.

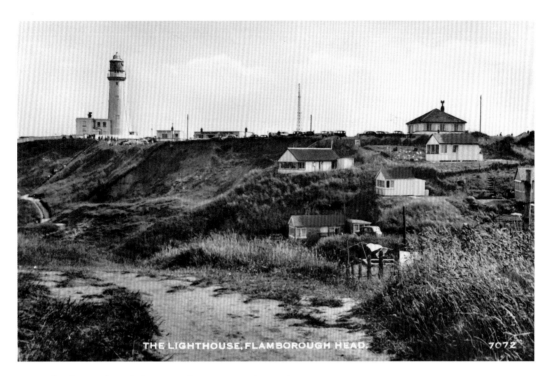

Flamborough Lighthouse and cottages in the 1950s.

in comfortable farms and villages and splendid churches with tall spires. To the seaward side, many of the old settlements have gone, lost to the sea, and other hamlets and villages are now closer to the shore than they once were. Ancient towns such as Bridlington have morphed into large and affluent residential areas behind the seaside resorts of their Victorian and Edwardian heydays. Small settlements such as Hornsea barely existed 200 years ago, became thriving holiday locales, and are now reborn as pleasant places to reside.

Coastal Wildlife in the Raw

From Spurn in the south to high Bempton Cliffs in the north, this is a landscape of extremes and contrasts. Above all, along the shoreline, you experience nature in the raw where land and sea collide. At different times of year, the wildlife varies along the shore, inland, and out to sea, and whichever way you turn, you experience something new and different. Autumn and spring bring massive movements of birds and of insects, such as butterflies and even aphids or ladybirds. At sea, the birds move, sometimes in vast flocks depending on the seasons and the weather. Breeding birds inhabit the lowland habitats along the bay, and occur spectacularly in the great seabird cities at Flamborough and Bempton. Look out too for grey seals, harbour porpoises and dolphins, and even gigantic sperm whales.

With the sea ever-present, wildlife is seen all along this coast and even in the built-up areas such as Bridlington Harbour, where a rare Mediterranean gull was once a regular winter resident, and the uncommon purple sandpipers huddle against the massive harbour walls. The seashore offers walks and recreation, and the coastal walk from Bridlington along the Sewerby Cliffs to Flamborough and beyond is one of Yorkshire's wonders.

The Viking Coast is to be discovered and then savoured.

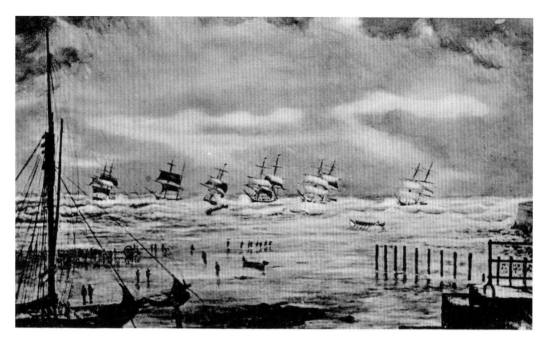

The Great Storm in Bridlington Bay, 10 February 1871.

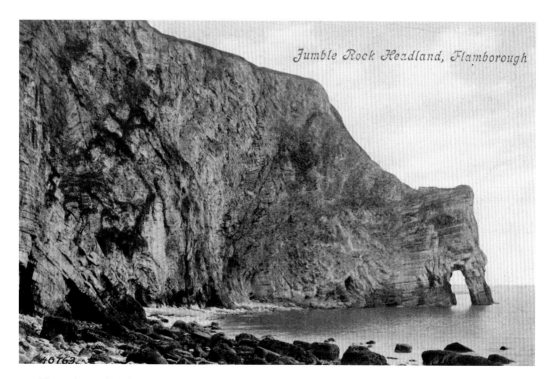

Jumble Rock Headland, Flamborough, around 1906.

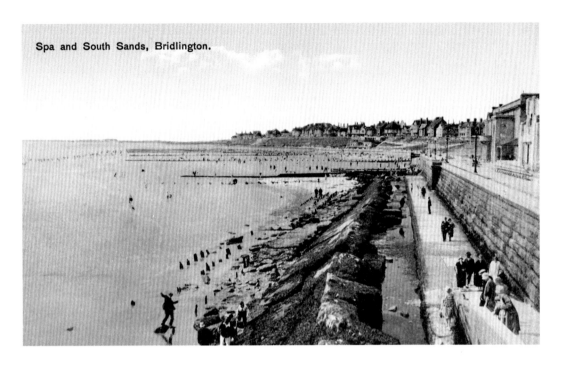

Spa and South Sands, Bridlington.

Above: The Spa and South Sands, Bridlington, 1930s.

Right: Map of Holderness in the 1600s.

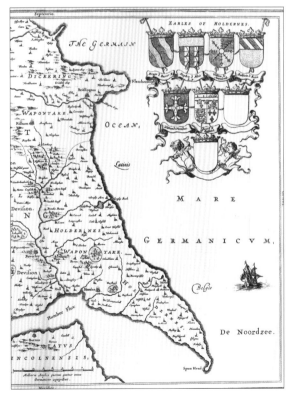

The High Cliffs & Seabirds of Bempton & Flamborough

And the strangest fact concerning the promontory is the isolation of its inhabitants from the rest of the county, a traditional hatred for strangers having kept the fisherfolk of the peninsula aloof from outside influences. They have married among themselves for so long, that it is quite possible that their ancestral characteristics have been reproduced, with only a very slight intermixture of other stocks, for an exceptionally long period. On taking minute particulars of ninety Flamborough men and women, General Pitt Rivers discovered that they were above the average stature of the neighbourhood, and were, with only one or two exceptions, dark-haired. They showed little or no trace of the fair-haired element usually found in the people of this part of Yorkshire. It is also stated that almost within living memory, when the headland was still further isolated by a belt of uncultivated wolds, the village could not be approached by a stranger without some danger.

Gordon Home, *Yorkshire* (1908)

From Spurn Head to Flamborough and Bempton Cliffs, this coastline boasts some of the most spectacular scenery in Britain. These landscapes are not only important as spectacular countryside and wildlife habitats, but are also rich in prehistoric and other heritage features. The small towns of Flamborough and Bempton have unique local histories and even today are different and distinctive from the rest of the area. Bridlington Bay sweeps majestically round the coastline to display to the viewer on the great chalk cliffs all the settlements, large and small, from Bridlington to Withernsea and Spurn. Flamborough is the jewel in the crown of Holderness. Flamborough village is situated around 4 miles (6 km) north-east of Bridlington on the dramatically prominent Flamborough Head. The most striking manmade feature is Flamborough lighthouse, though there are two, the old and the new. The 8-mile-long headland extends nearly 6 miles (10 km) into the North Sea and the northern chalk cliffs rise to around 400 ft (120 m). Flamborough Head (/ˈflæmbərə/ or /-brə/) is a promontory that separates Filey Bay and Bridlington Bay, a chalk headland, with sheer white cliffs. The clifftop has two standing lighthouse towers, the oldest dating from 1669 (designated a Grade II* listed building by English Heritage in 1952), with Flamborough Head Lighthouse built in 1806. The cliffs provide nesting sites for many thousands of seabirds, and are of international significance for their geology.

A beautiful view from the churchyard includes the whole sweep of the bay, cut off sharply by the Brig on the left hand, and ending about eight miles away in the lofty range of white cliffs extending from Speeton to Flamborough Head. The headland itself is lower by more than 100 feet than the cliffs in the neighbourhood of Bempton and Speeton, which for a distance of over two miles exceed 300 feet. A road from Bempton village stops short a few fields from the margin of the cliffs, and a path keeps close to the precipitous wall of gleaming white chalk.

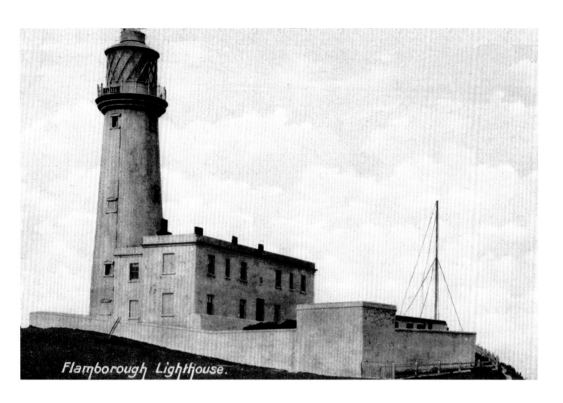

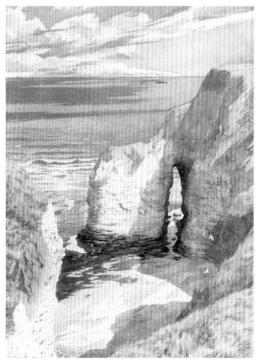

Above: Flamborough Lighthouse in the
early 1900s.

Right: The outermost point at Flamborough
Head from Gordon Home, 1908.

We come over the dry, sweet-smelling grass to the cliff edge on a fresh morning, with a deep blue sky overhead and a sea below of ultramarine broken up with an infinitude of surfaces reflecting scraps of the cliffs and the few white clouds. Falling on our knees, we look straight downwards into a cove full of blue shade; but so bright is the surrounding light that every detail is microscopically clear. The crumpling and distortion of the successive layers of chalk can be seen with such ease that we might be looking at a geological textbook. On the ledges, too, can be seen rows of little whitebreasted puffins; razor-bills are perched here and there, as well as countless guillemots. The ringed or bridled guillemot also breeds on the cliffs, and a number of other types of northern sea-birds are periodically noticed along these inaccessible Bempton Cliffs. The guillemot makes no nest, merely laying a single egg on a ledge. If it is taken away by those who plunder the cliffs at the risk of their lives, the bird lays another egg, and if that disappears, perhaps even a third.

Gordon Home, *Yorkshire* (1908)

Flamborough Village

The history of Flamborough was written by Frank Brearley in 1971, and gives a fascinating insight into this remarkable village and the associated headland. In 1870–72, John Marius Wilson's *Imperial Gazetteer of England and Wales* described Flamborough as follows:

FLAMBOROUGH, a village and a parish in Bridlington district, E. R. Yorkshire. The village stands in a hollow, near the centre of a promontory, 2 miles E of Marton r. station, and 4 NE by E of Bridlington. It was known to the Saxons as Fleamburg, signifying 'light town'; and it is supposed to have derived its name either from a flame-tower or beacon erected near it at some early period, or from the Continental town of Flansburg, belonging to the Jutes. It evidently is a place of much antiquity; it is even supposed to have been an important Roman station; and it probably continued to be somewhat notable in the middle ages; but it is now little if anything more than an ordinary fishing village, and coast-guard station...

It was also described as:

FLAMBOROUGH, a parish in the wapentake of Dickering; 4½ miles NE. of Bridlington, and 21 SE. of Scarborough. A very ancient station, formerly of some note, but at present merely a fishing village, situated in the centre of the promontory. The population of Flamborough amounts to 917, of which number, the fishermen and their families constitute at least one half. In addition to the church of St. Oswald mentioned above, there are here a Methodist chapel, and a chapel for the Primitive Methodists.

Other occupations of nineteenth-century Flamborough residents included 11 farmers, 2 blacksmiths, 2 butchers, 2 grocers, 7 carpenters, 4 shoemakers, 3 tailors, a stonemason and flour dealer, a bacon and flour dealer, a weaver, a corn miller, a straw hat manufacturer, and the landlords of The Sloop, The Board, and The Dog and Duck public houses. There was also a schoolmaster and a gentlewoman. Four carriers operated in the village, their destinations being Hull and York twice a week, and Bridlington, daily.

According to George Lawton in 1842, around Domesday (1086) this ancient settlement was 2,980 acres in Dickering wapentake. Lawton estimated the population to be 975; today, it is a little over 2,000. Flamborough was part of the possessions of King Harold Godwinson when he came to the throne, and valued at £24:

The town of Flamborough contains sixteen carucates and four oxgangs of land, of which the Church is endowed with six (or sixteen) bovates, of the fee of William Constable, who held ten carucates of land of the Honor of Chester.

However, at the Domesday Survey, its value was only 10s; this was after the 'wasting' of the north by William 'The Bastard' of Normandy. William fitz Nigel gave the church of St Oswald to the priory of Bridlington, to which it was appropriated; confirmed by popes Eugenius III and Celestine III, tithe fish were referred there in 1260. St Oswald's is a Grade II listed building, and there are the remains of Flamborough Castle, a medieval fortified manor house.

Bempton & Buckton

Bempton and Buckton villages are close to the border with North Yorkshire, just inland from the North Sea coast and Flamborough Head. Bempton is around 4 miles (6.4 km) north of Bridlington on the B1229 road between Speeton and Flamborough, and has Bempton railway station on the Yorkshire Coast Line between Hull and Scarborough. The combined population of the two settlements is just over 1000.

Dating back to at least the thirteenth century, the parish church of St Michael is a Grade II* listed building. The village is well known for its location close to the dramatic chalk cliffs, and today, the Bempton Cliffs RSPB Nature Reserve. The latter is famous for its breeding seabirds, including gannet, puffin, razorbill, common guillemot, kittiwake and fulmar. Bempton was formerly home to RAF Bempton, an early warning station, and some of the old buildings are still visible near the clifftop. As evidenced by Bronze Age pit dwellings close to the village, people have occupied the area since prehistoric times.

History & Heritage – Danes Dyke

Coming to Flamborough Head along the road from the station, the first noticeable feature is at the point where the road makes a sharp turn into a deep wooded hollow. It is here that we cross the line of the remarkable entrenchment known as the Danes' Dyke. At this point it appears to follow the bed of a stream, but northwards, right across the promontory – that is, for two-thirds of its length – the huge trench is purely artificial. No doubt the vallum on the seaward side has been worn down very considerably, and the fosse would have been deeper, making in its youth, a barrier which must have given the dwellers on the headland a very complete security.

Like most popular names, the association of the Danes with the digging of this enormous trench has been proved to be inaccurate, and it would have been less misleading and far more popular if the work had been attributed to the devil. In the autumn of 1879 General Pitt Rivers dug several trenches in the rampart just north of the point where the road from Bempton passes through the Dyke. The position was chosen in order that the excavations might be close to the small stream which runs inside the Dyke at this point, the likelihood of utensils or weapons being dropped close to the water-supply of the defenders being considered important. The results of the excavations proved conclusively that the people who dug the ditch and threw up the rampart were users of flint. The most remarkable discovery was that the ground on the inner slope of the rampart, at a short distance below the surface, contained innumerable artificial flint flakes, all lying in a horizontal position, but none were found on the outer slope. From this fact General Pitt Rivers concluded that within the stockade running along the top of the vallum the defenders were in the habit of chipping their weapons, the flakes falling on the inside. The great entrenchment of Flamborough is consequently the work of flint-using people, and is not later than the Bronze Period.

Gordon Home, *Yorkshire* (1908)

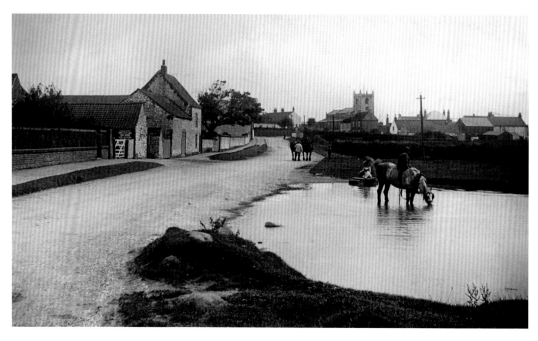

Flamborough Village, pictured around 1917, with horses being watered in the village pond.

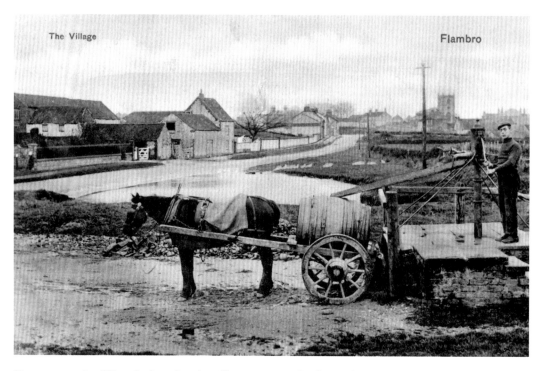

The water carrier filling the barrel at the village pump at Flamborough in the early 1900s.

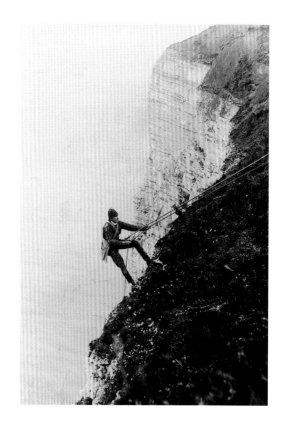

Right: Bempton climmer, 1922.

Below: Bempton village with the water carrier filling the butt at the village pond around 1914.

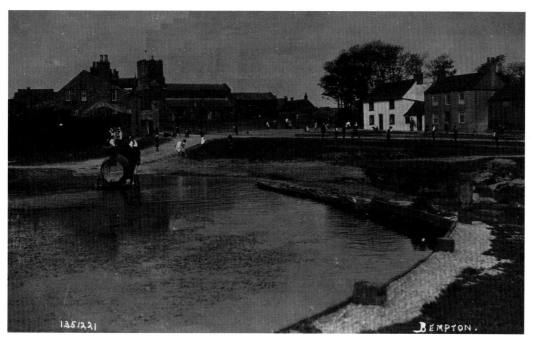

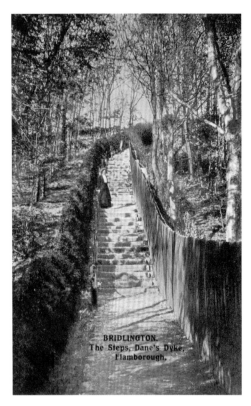

Left: The steps at Danes Dyke, early 1900s.

Below: Danes Dyke, *c.* 1906.

Today a local nature reserve, Danes Dyke is a 2-mile (3.2-km) long ditch that runs north to south isolating the seaward 5 square miles (13 km²) of the headland. The dyke and the steep cliffs make the enclosed land with its two boat-launching beaches, North and South Landings, easily defendable. Despite its name, the Dyke is of prehistoric origin, and when Pitt-Rivers excavated it in 1879, Bronze Age arrowheads were found.

The Cliffs & Seabird Cities

Including large sections that are now major nature reserves, the cliffs at Flamborough Head are a Site of Special Scientific Interest (SSSI) for both geological and biological significance. First designated in 1952, the SSSI area extends from Sewerby round the headland to Reighton Sands. The remarkable seabird cities have an estimated 200,000 nesting seabirds, including one of only two British mainland gannetries.

Relatively resistant to erosion, Bempton's hard chalk cliffs offer abundant sheltered headlands and crevices for nesting birds. The cliffs run around 6 miles (10 km) from Flamborough Head north towards Filey, at points towering over 330 feet (100 metres). There are good walks along the clifftops and the nature reserves have well fenced, safe observation points. For the beginner this is a great site to visit with keen birdwatchers (plus telescopes and binoculars on hand to help).

With nearly 400-foot sheer chalk plunging into the North Sea, where the rocks are a graveyard for over 200 ships and boats, Bempton Cliffs would be awesome even if lifeless. Yet this is the largest accessible seabird colony in the United Kingdom, a raucous squawking, moaning bird colony of over 100,000 nests. Today, birdwatchers throng the area, but watching from here has been part of this landscape for centuries. The Romans had lookout points along this coast to watch for the Saxons, and later the Saxons kept fires ready on the cliffs to warn local villages of Viking longship raids. Just inland from the cliffs the haunting remains of concrete bunkers from the 1950s are a harsh reminder of the Cold War. Wartime wreckage is strewn along the beach with the metal remains of a submarine gradually breaking up with time and tide. As elsewhere around the coast, locals have sometimes made money from scavenging seashore wrecks.

Geology of Spectacular Chalk Sea Cliffs

The headland is the only northern chalk sea cliff in Britain, the SSSI showing strata from the Upper Jurassic through to Cretaceous periods. The headland reveals a complete sequence of the so-called Chalk Group North Sea Basin strata, around 100 million to 70 million years old. The tall, white cliffs of Flamborough and Bempton provide dramatic contrast to the low glacial boulder clay coast that dominates Holderness to the south, the chalk deeply buried underground with soft erodible clays at the surface. These northern chalk cliffs have more caves than at any other British chalk site. The biggest caves extend over 50 metres inland from their coastal entrances. Along with caves are stacks, natural arches and blowholes, forming an internationally significant geological heritage.

Seabirds & Clifftop Wildlife

Vaughan (1998) provided an excellent account of the bustling seabird cities of the chalk cliffs. Seabirds such as gannets, kittiwakes and puffins breed abundantly on the cliffs and Bempton Cliffs, on the north side of the headland, has an RSPB Nature Reserve and visitor centre. This was a significant place in the history of British bird protection when, in his 1868 speech to the British Association for the Advancement of Science, Professor Alfred Newton condemned the shooting of seabirds at Flamborough Head. Subsequently, local MP Christopher Sykes introduced the Sea Birds Preservation Act 1869, the first modern legislation to protect wild birds for conservation in the United Kingdom.

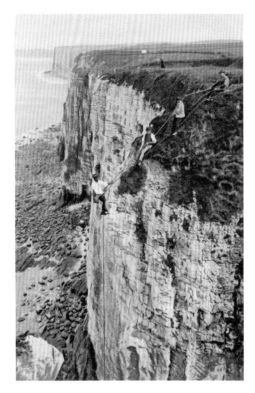

Left: Flamborough egg climbers at Bempton Cliffs around 1907.

Below: North Sea Landing at Flamborough around 1904.

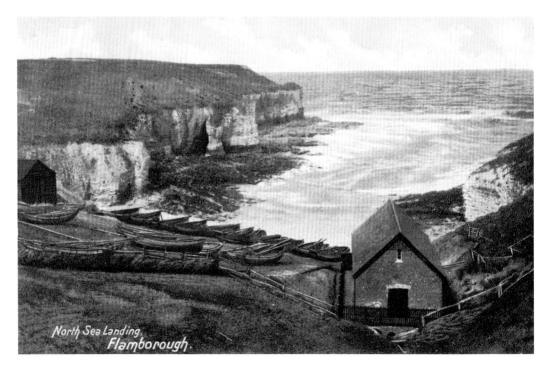

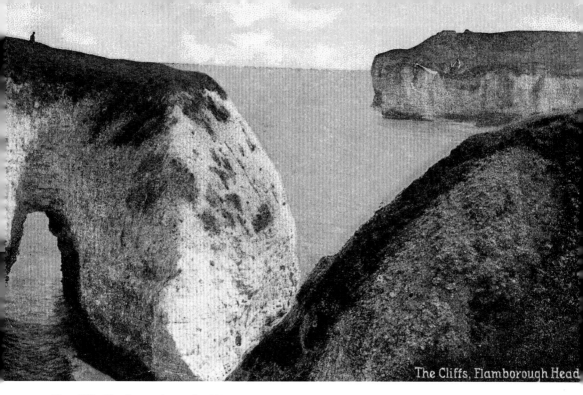

The cliffs, Flamborough Head, 1908.

Because it projects into the sea, Flamborough Head attracts many migrant birds in autumn, and is a key point for observing passing seabirds. When the wind is in the east, many birdwatchers scan for seabirds from below the lighthouse, or later in the autumn they search the hedges and valleys for terrestrial migrants. Strategically important for bird migration studies, Flamborough Head has a bird observatory.

Bempton Cliffs is home to the only English mainland breeding colony of gannets, by the 1970s boasting around seven or eight pairs. The birds arrive around January and leave in August and September. With about 10 per cent of the UK population nesting here, the most common birds are kittiwakes. At most UK sites, puffins use burrows, but at Bempton they nest in rock crevices, so although there are around 6,000 birds, it is hard to get a close view. Nevertheless, there are lots visible in May and June, Bempton's puffins flying 25 miles (40 km) east to Dogger Bank feeding grounds. Their numbers are vulnerable to reduced sand eel numbers caused by global warming or overfishing. A 2-degree centigrade rise in local sea temperatures has pushed plankton northwards.

Bempton Cliffs, Climmers & Shooters

The mid-twentieth-century diary of George Rickaby, a Bempton climber or climmer, was edited by James Whitaker and published as a book in 1997. This provides a fascinating account of the old practices. Bempton cliffs and its wild birds first became famous when a Mr Wade visited the area in the nineteenth century. He climbed the cliffs and wrote of what he saw, repeated in the *Scarborough Mercury* on 15 July 1927.

To the tripper and the ordinary visitor all the birds look much alike, and yet they are of various species. There are kittiwakes and puffins and gulls and herring gulls and razorbills and guillemots.

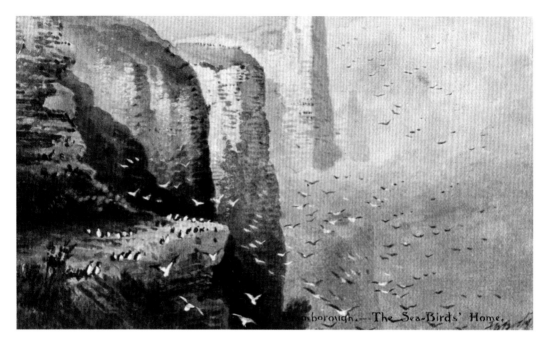

Flamborough, the seabirds' home, around 1904.

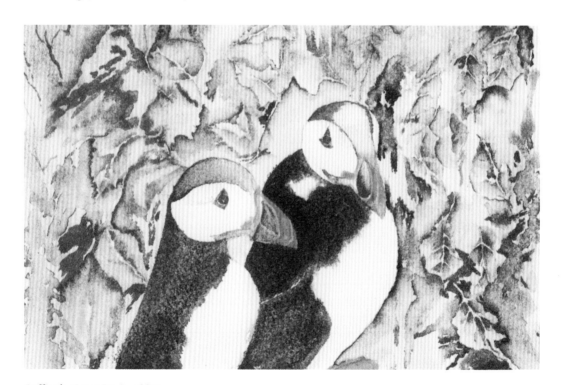

Puffins by Janet Davies, 2011.

If the birds all look alike, so do the cliffs, and yet these have their distinctive names and breeding places. Such names as Pigeons Hole, Weather Castle, Coffee Mill, tell of peculiarities in the shape of the cliffs, or of the birds, many of which have been handed down from father to son. Other names are 'White Wing' because a white guillemot was seen there; 'white bread loaf' because a man in distress begged of a climber who promised him the proceeds from this ledge, with which he bought the first white breadloaf he had had for some months.

The article explains how once every bay from Bempton to Flamborough was packed with breeding birds and the need for conservation was evident. So-called 'Kittihawks' were in demand for fashionable garb and were ruthlessly shot down and harvested. As a result of legislation, from 1880, all wild birds were protected between 1 March and 1 August. However, the Flamborough fishermen opposed the conservation proposals because they affected local livelihoods. They argued the need to control the population because the fish-eating birds adversely affected their fishing. In reality, the fishermen got fees from the culling and this was a relatively lucrative trade.

Bird egging was rather different from the shooting of the seabirds; farmer landowners held the rights to collect seabird eggs. They granted rights to local men, often their employees, to harvest eggs each spring. Mr Wade interviewed some of the climmers, one old climber telling him how,

Only two men used to go out, the one being let down and pulled up by the other, and he remembers how, when a boy, he was taken out to coil up the ropes and when his father found the weight too much for him he would be called to lend a hand and pull till the climber reached a place where the weight was taken off the man at the top.

On the steep, white chalk cliffs between Filey Bay and Flamborough Head, from the turn of the 1800s (and probably before) until at least 1950, the egg gatherers were at work. According to Norman Ellison, writing in 1919, up to 130,000 eggs were taken in a season. In the 1920s, many of the eggs were taken for food, but some went to processing dressed patent leather. Others were collected as specimens and competition raised prices of rare species or well-marked eggs. The season was from mid-May to late June, and became quite a tourist attraction, especially on the high cliffs of Speeton and Bempton. The precipitous, almost perpendicular cliffs have cracks and narrow ledges, with vast seabird colonies of guillemots, kittiwakes, puffins and razorbills. To the uninitiated, they were all 'seagulls' and got on well together. This was not the case in practice and the birds are aggressively competitive and territorial. The main herring gull rookery for example, was 7 miles away, immediately north of Filey Brig. Collecting from the seabird cities was an acquired skill, with four men in an egg gathering gang. With a rope attached to a metal spike driven into the ground near the clifftop, one man, suspended by the rope, climbed down to collect eggs. He could signal to his colleagues by a hand-line. His feet were used (similar to modern abseiling), to keep himself from striking the cliff face. Three men remained at the clifftop to hold the rope. After each climb, ropes were carefully examined for damage such as fraying. Further protection was a hard hat or other thick head covering to minimise risk from falling rocks and stones. These were easily dislodged by swinging ropes, startled birds and rabbits.

Generally, experienced climmers escaped serious injury, but not always. One such example was Joss Major, who, on 7 June 1910, received a blow to the head and fell unconscious. When the stricken climmer failed to respond to the usual signals, one of the support gang descended the cliff in search of him. Once the bad news got to the clifftop, a visitor from York, Mr H. Brown, set off for help. He first ran the 4 miles to Flamborough and then cycled to Bridlington for the local doctor. Dr Wetwan immediately drove to the scene

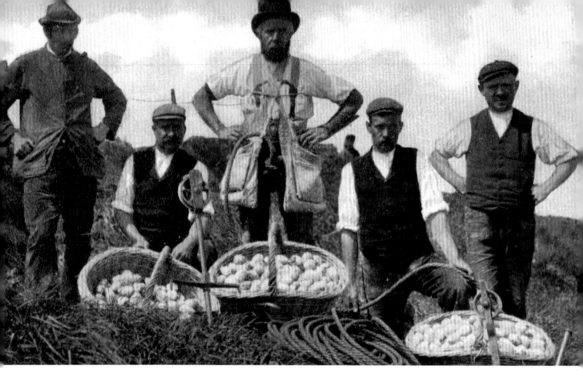

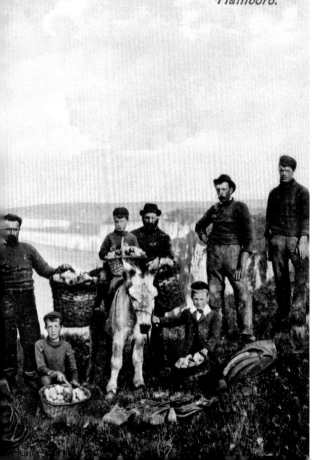

A good day's work with the Egg Climbers Flamboro.

Above: Climmers at Bempton Cliffs.

Left: The egg collectors (or climmers) at Flamborough around 1911, with a donkey carrying panniers of eggs.

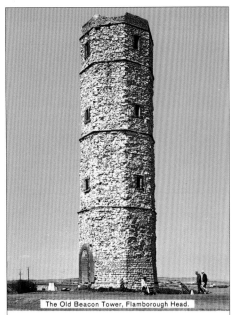

The Old Beacon Tower, Flamborough Head.

In the old days "Beacons" were erected to spread news of danger in times of war. Warning was given by means of a chain of lights, and at Flamborough the Beacon Tower still stands where the first coal fire beacon was lighted in 1674.
When on duty the Flamborough look-out watched Bridlington, and as soon as they saw a flare, that was the signal for them to fire their beacon, and so on to Rudston Parva, Bainton, Wilton and Holme to York.
When the Spanish Armada tried to reach our shores, beacons twinkled over the whole of the British Isles.

Right: The Old Beacon Tower at Flamborough Head.

Below: The evening after a storm at Flamborough, around 1900.

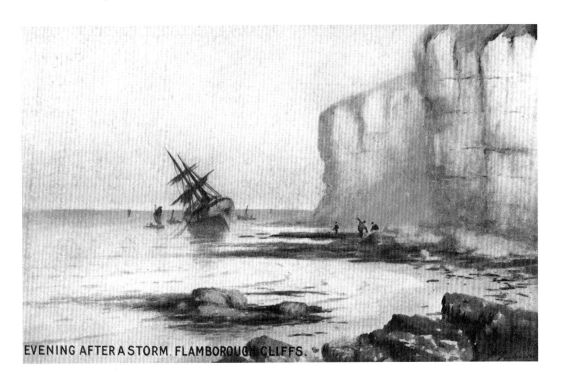

EVENING AFTER A STORM. FLAMBOROUGH CLIFFS.

of the accident and himself went over the cliff to the injured man. The doctor diagnosed a fractured skull and a bad cut to the head, and it seemed Joss could not be pulled up the cliff safely. Wetwan waited with him for eventual rescue by the rocket brigade or coastguard men, and the injured climmer was then taken to Lloyd's Hospital at Bridlington. When the intrepid Dr Wetwan finally appeared over the cliff edge, to cheering from group gathered at the spectacle, he asked what the fuss was. In his view it was simply a matter of duty since 'men and boys risked their lives daily for a few eggs'. Such accidents were rare and did not end the traditions of the egg gatherers and their dangerous occupation.

We gain some insight to this work from a unique piece of film from 1908, which captures a group of men, climmers, collecting eggs from the Flamborough clifftop bird nests. Carrying ropes, pickaxes, and other implements, the men emerge from a dugout above the cliffs. One of the men seated on the ground is holding a rope tethered to the ground with a metal spike. I recall in the 1970s that these metal spikes could still be seen at various points around the Bempton cliffs; by the 1990s, they had been lost to processes of erosion, but are seen in photographs from the time. In the film, another man climbs to the cliff edge and a third one abseils down the cliff, kicking away from the rock face and each time dropping back down. As he passes nest sites, he gathers their contents, which he places in bags attached to his waist. There follows a close-up shot of a man collecting eggs from the cliff face, presumably set up for the filming. Next, the film shows five men sitting above the cliff pulling the rope and the man hauling himself back up the rope and bouncing off the cliff face. The climmer then turns to the camera as he holds up an egg to view. The collection of eggs is then unloaded, firstly into a single basket. They are then separated into several baskets. The film shows the climmer holding a puffin in one hand and a guillemot in the other and staging a mock fight they struggle to escape.

A Unique Place in Nature Conservation History
Flamborough's birds were harvested by the climmers, but they were also shot in their hundreds by holidaymakers in boats out of Bridlington. Eventually, the controversy surrounding these practices led to legal action to stop the slaughter. This was a part of the gradual move towards modern nature conservation.

A Military History – The Battle of Flamborough Head, 1779
In the American War of Independence, on 23 September 1779, a Franco-American squadron fought the Battle of Flamborough Head with a pair of Royal Navy frigates. In the engagement, USS *Bonhomme Richard and Pallas*, with USS *Alliance*, captured HMS *Serapis* and HM hired ship the *Countess of Scarborough*, to become the best-known incident of the naval career of Capt. John Paul Jones. The toposcope at the Flamborough Lighthouse commemorates the 180th anniversary of the battle.

Flamborough in Writing & the Media
Bempton and Flamborough provide spectacular and remarkable scenery to stimulate writers and to set the scene for dramatic events. The BBC's Norman Ellison wrote about the area in his 1949 *Roving With Nomad*. Then Betty Bowen took Flamborough Head and village as the setting for the 1955 book, *Bill Takes the Helm*, in which an American boy struggles to save his grandmother's house from destruction by the sea. The drama plays out as he desperately trying to get used to post-war England, where he has been sent with his sister after his mother's death.

Along with books, Flamborough Head featured on the television programme *Seven Natural Wonders* as one of the wonders of Yorkshire, and made a surprisingly brief appearance in the first series of *Coast*. It also featured in the ITV drama *Scott & Bailey* as a setting for the finale of series three. Most recently, North Landing beach was used as a film location for the 2015 remake of *Dad's Army*. The allure of Flamborough continues.

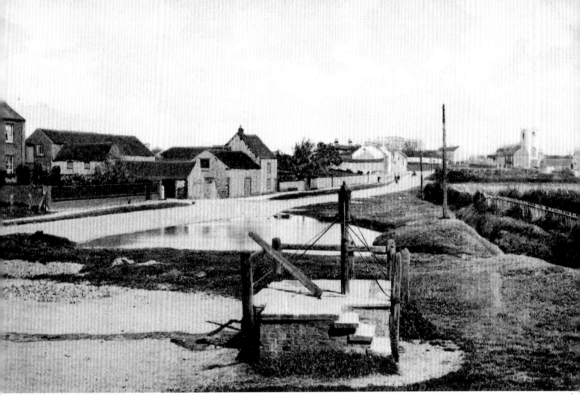

Above: The parish pump and village pond at Flamborough in the early twentieth century.

Right: Flamborough Lighthouse with horse and carriage and the washing out, about 1900.

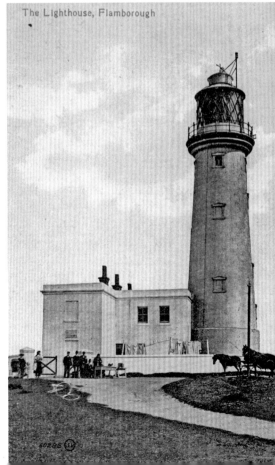

The Lighthouse, Flamborough

Bridlington – Medieval Fishing Harbour to Modern Tourist Town

Bridlington has a history that is too long and rich to cover adequately here. The reader is directed to the history of Bridlington written by David Neave in 2000. This thoroughly researched volume describes the development of Bridlington as a market town, port and seaside resort. Bridlington has been called Berlington, Brellington and Britlington, before it acquired the contemporary name with the Victorians. If Kingston-upon-Hull is the 'Lord' of Holderness, then Bridlington is surely the 'Lady'. The town is a peculiar mix of affluent, smart suburbs, remarkable historic areas, an ancient but now somewhat dilapidated harbour, and some quite poor estates. Over the years, Bridlington has experienced the best and the worst of tourism boom and bust, and today is gradually re-emerging into a brighter future.

> At the point where the chalk cliffs disappear and the low coast of Holderness begins, we come to the exceedingly popular watering-place of Bridlington. At one time the town was quite separate from the quay, and even now there are two towns – the solemn and serious, almost Quakerish, place inland, and the eminently pleasure-loving and frivolous holiday resort on the sea; but they are now joined up by modern houses and the railway-station, and in time they will be as united as the 'Three Towns' of Plymouth. Along the sea-front are spread out by the wide parades, all those 'attractions' which exercise their potential energies on certain types of mankind as each summer comes round. There are seats, concert-rooms, hotels, lodging-houses, bands, kiosks, refreshment-bars, boats, bathing-machines, a switchback-railway, and even a spa, by which means the migratory folk are housed, fed, amused, and given every excuse for loitering within a few yards of the long curving line of waves that advances and retreats over the much-trodden sand.
>
> The two stone piers enclosing the harbour make an interesting feature in the centre of the sea-front, where the few houses of old Bridlington Quay that have survived, are not entirely unpicturesque.
>
> George Home, *Yorkshire* (1908)

So even in 1908, Home was mourning the loss of most of the older 'picturesque' buildings around the harbour, old Bridlington Quay.

Bridlington & Old Burlington

Around 24 miles (39 km) north of Kingston-upon-Hull, Bridlington is the main coastal town on the northern Holderness Coast, at times a significant port and harbour and an active fishing town. There is evidence of settlements in the area from Bronze Age and Romano-British times. The Gypsey Race river runs through Bridlington to join the North Sea via the harbour. Today, for the final part of its journey, the river is underground in a culvert from the Quay Road car park. A minor sea fishing port with a working harbour,

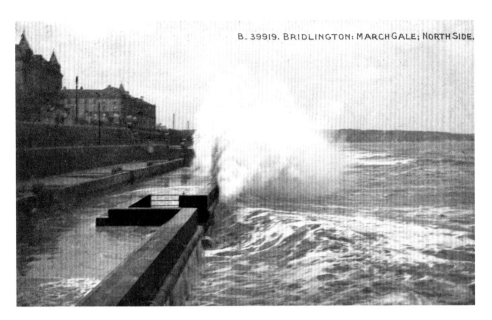

A March gale on the front at Bridlington North Side, probably early 1900s.

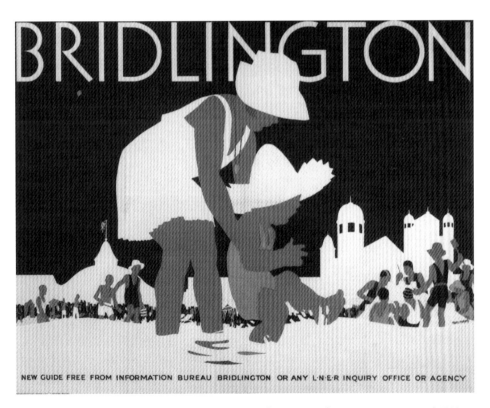

Bridlington advertising from the North Eastern Railway poster by Tom Purvis around 1930.

famed for its fish and shellfish, modern Bridlington, a noted tourist destination, has a resident population of around 35,500. In the latter twentieth century, with tourism struggling to adapt to changing demographics and tourist behaviour, Bridlington's popularity declined with the boom in cheap foreign holidays. Changes in the industrial north of England during the 1970s and 1980s, with the loss of so-called 'works weeks', compounded the issues, and the days of mass tourism to Bridlington and similar resorts ended. Today there are signs of a recovery in fortunes.

The history of tourism and holidaying along the Holderness Viking Coast is of dramatic rise and gradual fall or retraction to changed leisure landscapes of the twenty-first century. Holderness is now emerging from the 1970s doldrums, and Bridlington encapsulates wider tourism trends, but with secret places and a rich heritage. The latter includes the magnificent Bridlington priory and old Burlington Town. The church, with its abbeys and monastic land-holdings, played a major part in this region, with Bridlington priory as a major administrative centre. At the core of Bridlington lie the old harbour and the still active fishing industry, and soon, a new marina for leisure boats.

The Bridlington shore has the highest coastal erosion rate in Europe. The southern coast is low boulder clay cliffs and sand dunes, but to the north are steep, dramatic rocky cliffs, the great spur of Flamborough Head projecting eastward into the North Sea. However, in a region beset by coastal erosion, a sea wall and wide beach with wooden groynes to hold the sand to protect Bridlington's seafront. Part of a large deposit of sand stretching into the bay, the beaches and sandbanks are important marine wildlife habitats. Like Scarborough to the north, Bridlington boasts spectacular sandy North and South beaches with environmental quality marques. Marking where the Old Town starts, the Hull–Scarborough railway line divides the town from south-west to north-east. Bridlington Old Town, north of the line, has retail outlets, industrial estates and large residential areas. Old Burlington, as it is known, includes remarkably historic and attractive streets of eighteenth-century town houses and shops, which, along with the priory, are missed by most visitors to modern Bridlington. However, south of the line are the main modern tourist attractions with holiday accommodation and residential housing. As modern Bridlington grew, it incorporated Hilderthorpe village. Early in its history, Bridlington was a small fishing port on the coast known as Bridlington Quay; following the discovery of a chalybeate spring in the town, the nineteenth-century quay became a popular seaside resort. Subsequently, in 1805, Bridlington's first hotel opened and, with the coming of the railway in 1846, the town became popular with West Riding industrial workers from Sheffield to Leeds and beyond. The railway station opened between the old quay and the historic town of Old Burlington. As the area around the 'new' railway station developed, the two parts of the town came together. Although commercial fishing has declined, the port remains popular with sea anglers for coastal day trips. Bridlington has lucrative export markets for shellfish to France, Spain and Italy, said to be worth several million pounds a year.

Bridlington Priory & Parish Church

Close to Old Burlington, Bridlington priory, also known as the priory church of St Mary, is a Grade I listed building. The present structure was built on the site of an Augustinian priory, lost in the 1500s under the Dissolution of the Monasteries, and incorporating much of the earlier building. The priory was once fortified, the Bayle Gate (a Grade I listed building) from that defensive structure remaining as evidence, and other remains are visible in the grounds.

In old Bridlington there stands the fine church of the Augustinian Priory we have already seen from a distance, and an ancient structure known as the Bayle Gate, a remnant of

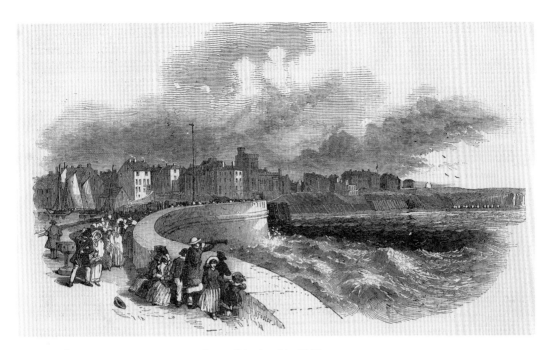

Bridlington Quay – a watering place of England in 1849.

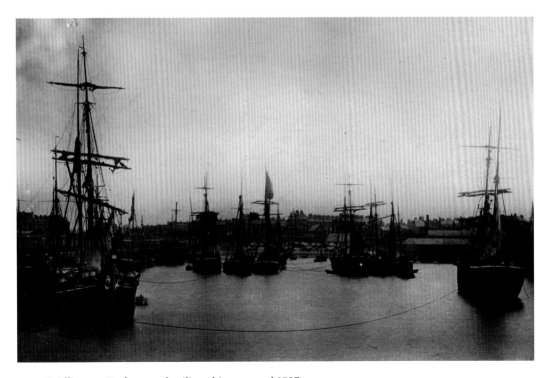

Bridlington Harbour and sailing ships, around 1907.

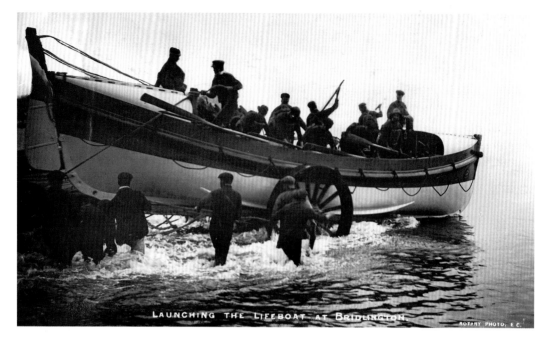

Launching the lifeboat at Bridlington in the 1920s.

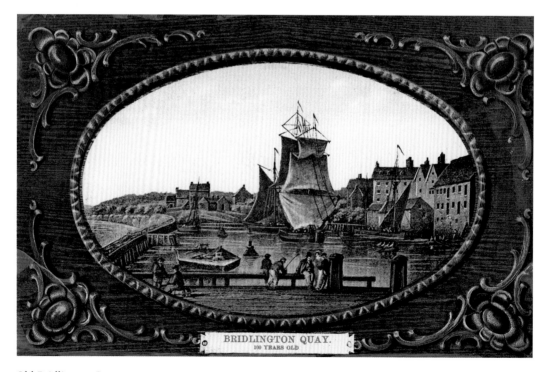

Old Bridlington Quay.

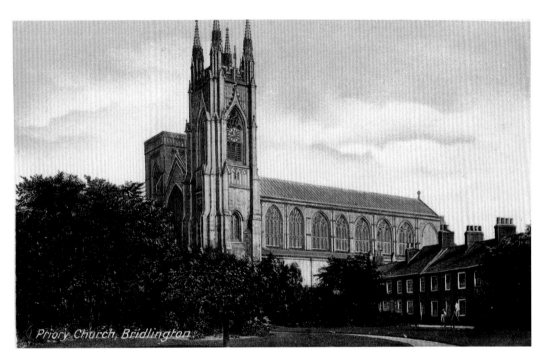

Bridlington priory church in the mid-twentieth century.

the defences of the monastery. They stand at no great distance apart, but do not arrange themselves to form a picture, which is unfortunate, and so also is the lack of any real charm in the domestic architecture of the adjoining streets. The Bayle Gate has a large pointed arch and a postern, and the date of its erection appears to be the end of the fourteenth century, when permission was given to the prior to fortify the monastery. Unhappily for Bridlington, an order to destroy the buildings was given soon after the Dissolution, and the nave of the church seems to have been spared only because it was used as the parish church. Quite probably, too, the gatehouse was saved from destruction on account of the room it contains having been utilized for holding courts. The upper portions of the church towers are modern restorations, and their different heights and styles give the building a remarkable, but not a beautiful outline. At the west end, between the towers is a large Perpendicular window, occupying the whole width of the nave, and on the north side the vaulted porch is a very beautiful feature.

Gordon Home, *Yorkshire* (1908)

The Spa

At the heart of the late Victorian seaside resort was Bridlington Spa, originally opened in 1896, and in its heyday a leading entertainment venue at which many well-known entertainers appeared. However, by 2005, the state of the building deteriorated badly and the East Riding Council commissioned a full and thorough refurbishment. The venue has since developed a new lease of life, continuing to attract big name performers to the main leisure town of the Holderness coast.

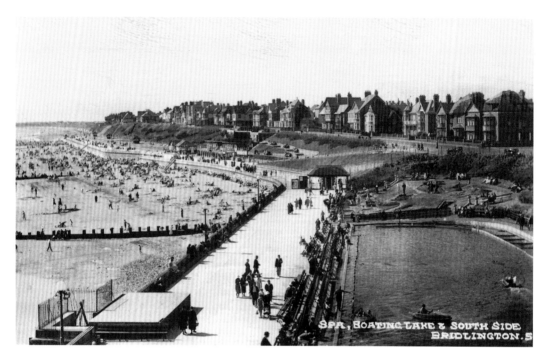

Spa, boating lake, and south side, Bridlington, around 1954.

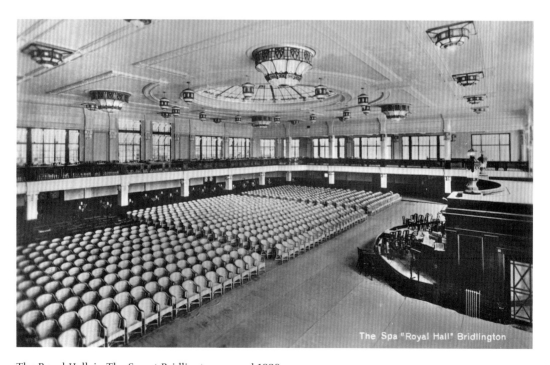

The Royal Hall, in The Spa at Bridlington around 1930.

A Long History

The origins of human settlement at Bridlington are not well known but they clearly extend back to prehistoric times. Bronze Age Danes Dyke is a 2.5-mile (4-km) long, manmade dyke on Flamborough Head to the north of Bridlington. There are suggestions that Bridlington was the site of a Roman garrison. It is known that the fourth-century Count Theodosius built signal stations on the North Yorkshire, to warn of Saxon raiding parties, but most evidence of earlier settlements has long since been lost to the sea. However, a Roman road does run into Bridlington and Roman coins found in the area, though that in itself is not unusual. Interestingly, along with two Greek coins dating from the second century BC, two Roman coin hoards were found in the old harbour area, perhaps indicating the port was used well before the Roman invasion. The Roman maritime station of Gabrantovicorum may have been near modern Bridlington, since in the early second century Ptolemy described the bay in his *Geography* as 'Gabranticorum Sinus, with many harbours'. No traces of early harbours remain, the sea destroying the evidence of the signal station at Flamborough Head (probably on Beacon Hill where there is now a gravel quarry), and perhaps a fort somewhere close to the harbour. From the Headland, a keen-eyed observer can see Filey, Scarborough Castle, and even the Whitby promontory beyond. To the south is a good view of Bridlington Bay sweeping down to the entrance to the Humber – a commanding position indeed. A garrison based at Bridlington would be an ideally placed operational centre for the chain of signal stations guarding this important, vulnerable coastline.

Other archaeological remains include two possibly Bronze Age bowl barrows, called Butt Hills. Found near Dukes Park on the Parade in 1895, they are now ancient monuments. Close by, to the north, are remnants of an Anglo-Saxon cemetery discovered on farmland near Sewerby.

Aside from the Ptolemy's Roman reference to Bridlington Bay, the earliest documentation of Bridlington is the 1086 Domesday Book, stating, 'Bretlinton was the head of the Hunthow Hundred and was held by Earl Morcar before it passed into the hands of William the Conqueror by the forfeiture.' The post-Conquest survey gives an insight into the consequences of the 'Harrying of the North' with annual land value falling from £32 pre-Conquest to 8s (now 40p) at the time of the survey. By 1086, it was 'two villeins, and one socman with one and a half Carucate. The rest is waste.' Gifted to a Norman overlord, in 1072 the land went to Gilbert de Gant (or Gaunt), nephew of King Stephen. Thus, it passed to Gilbert's son Walter and his descendants, and in part to the Augustinian priory founded by Gilbert in 1133. The gift by Gilbert was confirmed in a charter by King Henry I and several later monarchs confirmed and extended the original gift to the monks. King Stephen also granted the right to have a port at Bridlington. In 1200, King John gave the prior permission to hold weekly markets and annual fairs. Henry VI permitted three annual fairs on the Nativity of Mary, and both the Deposition of, and the Translation of, Saint John of Bridlington in 1446. As shown in 1415 by the visit to the priory of Henry V to give thanks for his victory at Agincourt, Bridlington was growing in importance. The town grew around the priory, which expanded in influence until the Dissolution under Henry VIII. The last prior, William Woode, was taken prisoner and executed in 1538, after taking part in the northern insurrection known as the Pilgrimage of Grace. Following the Dissolution of the Monasteries, estates appropriated to the priory and convent, valued at £600 (at that time a fortune), passed to the Crown. The priory church today was saved because local people pleaded that they still needed a parish church for their services. Bridlington manor remained Crown property until granted by Charles I to Sir John Ramsey (recently created Earl of Holderness) in 1624. In 1633, Sir George Ramsey sold the manor to thirteen townsmen acting on behalf of the manor tenants; in May 1636, the thirteen men became lords feoffees (trust holders) of Bridlington Manor.

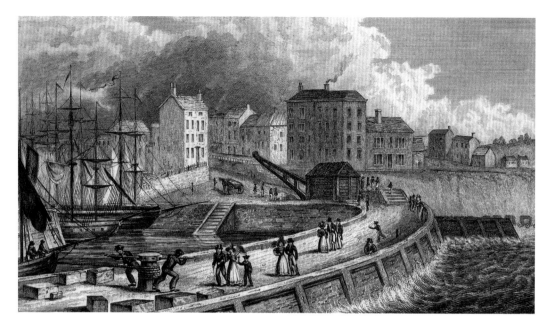

Bridlington Quay in the early 1800s, printed in 1830.

A little later, in 1643, again reflecting strategic importance, Queen Henrietta Maria of France landed at Bridlington with troops to support the Royalists in the English Civil War. She stayed at Bridlington before moving her headquarters to York. A detailed account of the Queen's brief but eventful stay at Bridlington is provided by Gordon Home (1908):

In 1642 Queen Henrietta Maria landed on whatever quay then existed. She had just returned from Holland with ships laden with arms and ammunition for the Royalist army. Adverse winds had brought the Dutch ships to Bridlington instead of Newcastle, where the Queen had intended to land, and a delay was caused while messengers were sent to the Earl of Newcastle in order that her landing might be effected in proper security. News of the Dutch ships lying off Bridlington was, however, conveyed to four Parliamentary vessels stationed by the bar at Tynemouth, and no time was lost in sailing southwards. What happened is told in a letter published in the same year, and dated February 25, 1642. It describes how, after two days' riding at anchor, the cavalry arrived, upon which the Queen disembarked, and the next morning the rest of the loyal army came to wait on her.

God that was carefull to preserve Her by Sea, did likewise continue his favour to Her on the Land: For that night foure of the Parliament Ships arrived at Burlington, without being perceived by us; and at foure a clocke in the morning gave us an Alarme, which caused us to send speedily to the Port to secure our Boats of Ammunition, which were but newly landed. But about an houre after the foure Ships began to ply us so fast with their Ordinance, that it made us all to rise out of our beds with diligence, and leave the Village, at least the women; for the Souldiers staid very resolutely to defend the Ammunition, in case their forces should land. One of the Ships did Her the favour to flanck upon the house where the Queene lay, which was just before the Peere; and before She was out of Her bed, the Cannon bullets whistled so loud about her, (which Musicke you may easily believe was not very pleasing to Her) that all the company pressed Her earnestly to goe

out of the house, their Cannon having totally beaten downe all the neighbouring houses, and two Cannon bullets falling from the top to the bottome of the house where She was; so that (clothed as She could) She went on foot some little distance out of the Towne, under the shelter of a Ditch (like that of Newmarket;) whither before She could get, the Cannon bullets fell thicke about us, and a Sergeant was killed within twenty paces of Her.

This military history is hard to associate with modern-day Bridlington, but perhaps reflects ancient origins and the significance of the safe harbour. Even the hustle and bustle of a busy Bank Holiday struggles to match a full Civil War encounter.

As noted earlier, Bridlington was two separate settlements growing together over time. Old Burlington was around 1 mile inland from the Old Quay, where today's harbour is. Henry VIII ordered the harbour walls improved and strengthened using masonry from the priory, and further improvements came in 1837 with an Act of Parliament passed to allow the old wooden piers to be replaced by new stone-built structures to the north and south. While the main activity of the harbour was now landing and processing fish, the port also imported and exported other goods such as corn. To this end, the corn exchange was built in the market place in 1826, and can still be seen today. There were also mills for grinding corn, and local breweries to make ale, activities continuing into the late twentieth century.

Bridlington's Archery Butts
Henry V's victory visit to Bridlington following Agincourt owed victory to English longbows. The importance of these weapons was reflected in the popularity of shooting with both crossbow and longbow among ordinary people. However, there was also strategic need for a trained and skilful army from the masses. To this end, in the fifth year of Edward IV's reign, an Act was passed commanding all able-bodied Englishmen between eighteen and forty-five years of age to be given a bow of his own height. In many parishes, shooting butts were built so bowmen could be trained and practice. Two archery butts, around 100 metres apart, were made near the priory church in Bridlington. The butts were mounds with fixed targets for marksmen to aim at, to help stop stray arrows from going too far. Today's 'Butts Close' street name is a reminder of the medieval necessity.

Storms, Wrecks & Lives Lost
All seaside settlements along this coast will have stories of shipwrecks with sailors or passengers lost at sea. Community involvement in lifeboats and coastguard stations is part of the way of life too.

On 18 March 1915 the *Lord Airedale* sank in a storm at Bridlington but was eventually re-floated and brought into harbour. She was a Grimsby trawler pressed into service as a minesweeper. On this particular day, a bad storm developed by late evening, and the lifeboat was despatched to rescue the stricken ship. First, but unsuccessfully, the Bridlington Rocket Brigade shot a breeches buoy line over the minesweeper. The next attempt was from the lifeboat *George and Jane Walker*. Local men, 250 soldiers from the Norfolk Regiment serving in the area, and four horses helped manoeuvre the lifeboat, which was launched once the crew were ready. However, the storm was so severe that the powerful waves lifted the horses from their feet and men were thrown into the violent waters. The lifeboat crashed down onto its own launching carriage, causing so much damage that the crowd on the beach was unable to haul it out. In the ensuing mayhem, one man, Robert Carr, was tangled in the harness and drowned. The lifeboat was taken as close as possible to the sinking vessel, but by low tide, the minesweeper's funnel and steering gear had gone and ten Grimsby sailors had perished along with Bridlington man, Robert Carr, and three horses. The *Lord Airedale* survived and was repaired to sail another day, but in 1916 struck a mine and sank with the loss of seven of her fourteen-man crew.

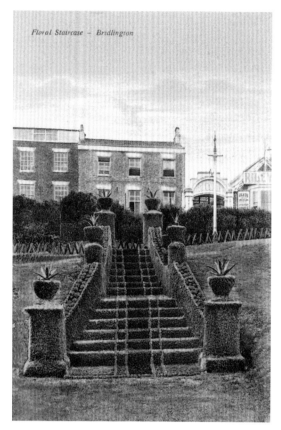

Left: The Floral Staircase Bridlington, probably 1920s.

Below: Storm at Bridlington around 1904, North Side.

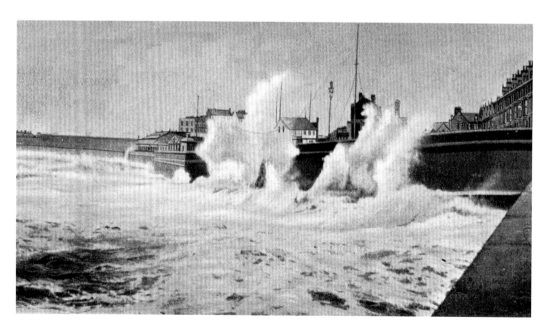

The Strange Story of the Wood-Boring Gribble

Harbours and ports with extensive wooden piers and other constructions are especially prone to damage from a small crustacean called the gribble. The name 'gribble' originally applied to wood-boring species of any of fifty or so marine isopods (like tiny woodlice); the first, *Limnoria lignorum*, was described from Norway in 1799 by Jens Rathke. *Limnoriidae* include seaweed and seagrass borers, and woodborers, the latter doing untold damage to wooden ships and harbour structures. Gribbles bore by digesting wood cellulose with *Limnoria lignorum*, *L. tripunctata* and *L. quadripunctata* being the most destructive. The tiny animals disperse around the world via infected ships, reducing marine timber structures such as jetties, piers, and ships to delicate honeycombs. Unfortunately, they are remarkably tolerant of creosote preservatives used to protect timber. By the 1800s, local scientists were writing with alarm about the destructive gribble. One account states:

> In December, 1815, I was favoured by Charles Lutwidge, Esq, of Hull, with specimens of wood from the piers at Bridlington-Quay which woefully confirm the fears entertained of their total ruin by the hosts of these pigmy assailants that have made good a lodgment in them, and which, though not so big as a grain of rice, ply their masticatory organs with such assiduity as to have reduced a great part of the wood-work which constitutes their food into a state resembling honeycomb.

The writer goes on:

> If this insect were easily introduced to new stations, it might soon prove as destructive to our jetties as the Toredo navalis to those of Holland, and induce the necessity of substituting stone for wood universally, whatever the expense, but happily it seems endowed with very limited powers of migration; for, though it has spread along both the South and East Piers of Bridlington harbour, it has not yet, as Mr Lutwidge informs me, reached the dolphin nor an insulated jetty within the harbour. No other remedy against its attacks is known than that of keeping the wood free from salt water for three or four days, in which case it dies; but this method, it is obvious, can be rarely practicable.

Brought to Bridlington on an infested vessel from a foreign port, by the 1870s, gribbles were at Yarmouth, Scarborough, and elsewhere and the search was on for an effective deterrent. With seven pairs of legs armed with sharp claws to cling to timbers while the females bite into the wood, gribbles are only 5mm long, though they cause thousands of pounds worth of damage.

Some Famous Bridlington People

Pilot Albert Richard August Van Hecke was a 28-year-old Belgian who, upon arriving in Britain after escaping Nazi occupation, joined 349 (Belgian) Squadron. Sadly, on 12 October 1943, he was discovered dead in the wreckage of his Spitfire at Bessingby Road, Bridlington, his widow receiving late news when she was released from a German concentration camp.

Herman Darewski, composer and conductor of light music, was Bridlington Musical Director from 1924–26 and 1933–39, and in 1902 worked there with Wallace Hartley, the leader of the orchestra, which famously played as the *Titanic* sank.

William Kent (1686–1748), renowned architect, landscape architect and furniture designer, was born in Bridlington.

Benjamin Fawcett, noted ornithologist and pioneering woodblock colour printer, was born in Bridlington in 1808. He worked on the books by Revd Francis Orpen Morris such as *British Birds*.

William of Newburgh, born in Bridlington, was a twelfth-century English chronicler and historian.

A. E. Matthews, an actor playing numerous character roles on stage and screen for eighty years, was born in Bridlington in 1869. He was notable as one of British cinema's earliest grumpy old men, featuring in many successful movies.

John Twenge (St John of Bridlington), born in Thwing around 10 miles from Bridlington, was Canon of Bridlington priory and became a fourteenth-century English saint.

Though he was born in Horsforth, West Yorkshire, Malcolm McDowell's parents owned a small hotel and bar in Bridlington and he sometimes worked there – at least before he was famous through films like *If...*, *O Lucky Man!*, *Caligula* and *A Clockwork Orange*.

Artist David Hockney, born in 1937, is closely associated with Bridlington.

And So to Holderness

Southwards in one huge curve of nearly forty miles stretches the low coast of Holderness, seemingly continued into infinitude. There is nothing comparable to it on the coasts of the British Isles for its featureless monotony and for the unbroken front it presents to the sea. The low brown cliffs of hard clay seem to have no more resisting power to the capacious appetite of the waves than if they were of gingerbread. The progress of the sea has been continued for centuries, and stories of lost villages and of overwhelmed churches are met with all the way to Spurn Head. Four or five miles south of Bridlington we come to a point on the shore where, looking out among the lines of breaking waves, we are including the sides of the two demolished villages of Auburn and Hartburn.

Gordon Home, *Yorkshire* (1908)

Barmston & Fraisthorpe

The area immediately south of Bridlington could not contrast more strongly with that to the north. Here the countryside is almost completely low-lying agriculture with several farmsteads, and the villages of Barmston and Fraisthorpe. The highest point is only 85 feet (26 metres) at Hamilton Hill, a triangulation point, and the A165 Bridlington Road passes through the parish. Barmston village gave its name to the ancient parish and ecclesiastical parishes of Barmston, bounded by watercourses of Earl's Dike (or Watermill Grounds Beck) to the north, and Barmston Drain to the south. In 1935, the civil parish was substantially enlarged with the addition of most of the parish of Fraisthorpe to the north, an increase of 1,995 acres (807 hectares). After the 1400s, nearby Hartburn, just south of the Earl's Dike coastal outflow, was deserted and lost to erosion. By the 1850s, the hamlet of Winkton in Barmston was also abandoned. Except for a single farm, Auburn village in the former parish of Fraisthorpe was lost to the sea, the chapel dismantled in the 1780s.

Baines's Directory of 1823 describes the area in the 1800s:

BARMSTON, a parish in the wapentake and liberty of Holderness; 6 miles S. of Bridlington. A pleasant village situated at the northern extremity of Holderness, it is

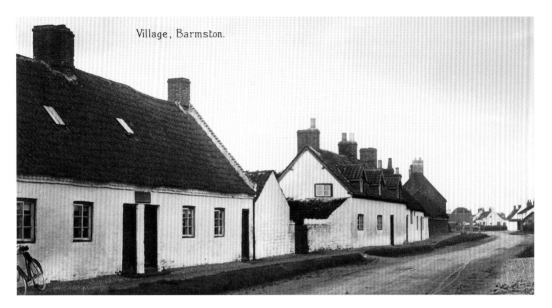

Village, Barmston.

Barmston village probably around 1915.

very near to the North Sea, and is much frequented by the people of the neighbouring villages, who come here to purchase gravel to repair their roads with, which is left in abundance on the shores of Barmston by every tide. The church is a very ancient building, dedicated to All Saints, of which the Revd John Gilby is rector; in the interior is a marble monument, representing in full figure a Scotch Lord, in armour, with a griffin at his feet. Population 205.

The nobleman whose memory this monument commemorates was the lord of the manor, which was given to him for his valour and essential services rendered to his country. In 1726, Sir Griffith Boynton founded an Alms-house here, for four old men, and endowed it with a small annual stipend for each.The repairs and stipend were charged by Sir Griffith upon the manor of Haisthorpe. The old Hall, anciently the residence of the Boynton family, is now occupied as a Farm-house. It is moated round. There is also a school and master's dwelling-house, built by Sir Francis Boynton, Bart, for the accommodation of the place; he is lord of the manor, and patron of the living.

Nearby Winkton was noted as '...in the parish of Barmston, wapentake and liberty of Holderness; 6 miles S. of Bridlington. Long since been swallowed up the sea', an ongoing issue and problem to this day.

As Nature Intended...

For many decades, Fraisthorpe sands was a favourite spot for naturists and I recall officially designated as a nudist beach in the 1970s. This always seemed a bold move when I consider being a small child sat on the beach at nearby Hornsea, turning blue as a north-easterly gale blew across Bridlington Bay. East coast nudists would need to be exceptionally hardy. However, in 1994, there was an even more chill wind when the beach's designated status was terminated. Today, East Riding Council signs warn that anyone committing acts of 'indecency' are liable to prosecution, and apparently the local constabulary are on the case.

Rudston

Inland from Bridlington is the tiny village of Rudston, named in the Domesday account as 'Roodston', meaning 'cross-stone' and relating to the remarkable Neolithic standing stone or monolith which stands almost 26 feet high in the churchyard, and extending around 20 feet into the earth. The stone, weighing around 25 tons, probably came from the Cleveland Hills in North Yorkshire. A local legend was that the stone fell from the sky and struck down a number of people desecrating the churchyard.

This remarkable settlement also boasted the site of a well-preserved Roman mosaic. This led to the discovery of Rudston Roman villa, first excavated in 1839, and re-excavated in the 1930s, 1960s, and 1970s. On 26 April 1933, while ploughing a field at Breeze Farm, Henry Robson unearthed stone fragments that turned out to be part of a Roman tessellated or mosaic pavement. In addition, part of a hypocaust underfloor central heating system was discovered. Building foundations including a workshop were uncovered and two pavements were in remarkably good condition. The smallest of the three, known as the Fish Pavement, was badly damaged by the plough. The first mosaic extended over 150 square feet of a room around 20 feet by 16 feet. The central design has Venus with two armlets and an apple in her right hand. Nearby a 'merman' holds a five-pronged fork, and long-tailed birds peck at fruit. Animal designs include a wounded lion, a bull, a stag in a pine forest, and a spotted leopard; the bull is inscribed 'Taurus Homicida' or 'Man-Slaying Bull'.

In the early 1960s, the finds were rescued and taken for display to Hull & East Riding Museum. According to the entry in *Bridlington Quay and Neighbourhood* (1868),

> In 1838 a tesselated pavement was discovered at Rudston in a field to the left of the road leading to Kilham. It was about nine feet long by four feet wide; the tessera a little over an inch square on the surface, composed of white, grey, red and blue colour; here, as in other instances, the hope of gain was the first consideration, and led to the destruction of the pavement without any drawing taken for a useful purpose.

In May 1938, F. R. Pearson MA, history master at Bridlington School from 1948 to 1952, wrote *The Roman Villa at Rudston*.

Sewerby Hall

John Greame, son of Robert Greame, was the first of the Greame family to live at Sewerby old manor house. On the death of his father in 1708, he became wealthy and bought the estate from Elizabeth Carleill. This Grade I listed Georgian country house is in 50 acres (20 hectares) of landscaped gardens at Sewerby, just north of Bridlington. The main block was built around 1714, with three storeys in brick and a seven-window frontage incorporating some older structures. In 1808, two-storey, bow-fronted wings and a semi-circular Doric portico were added. The building was painted as mock stonework, and the wings extended to three storeys. Greame built the present Sewerby Hall between 1714 and 1720, replacing the old manor house, which had been there for centuries. In 1746, aged eighty-three, John Greame I died. His son, John Greame II, died childless in 1798, aged ninety-eight. The latter's widow, Almary, remained in residence until her own death in 1812, the hall passing to a nephew, John Greame III. He had married heiress Sarah Yarburgh of Heslington Hall, York, and when Sarah died young, John Greame III remarried. He and his second wife moved to live with his Aunt Almary in Sewerby Hall, which he subsequently inherited.

John III commissioned various alterations, including a new portico in 1808, and on his death in 1841 ownership passed to his eldest son Yarburgh Greame. The latter, on inheriting his mother's estate at Heslington, took the surname Yarburgh, to become, remarkably,

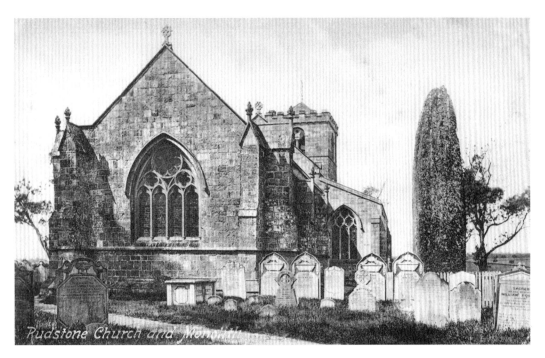

Rudston Church and Monolith, 1917.

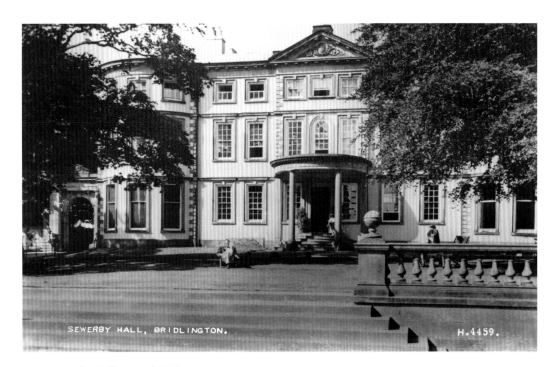

Sewerby Hall around 1955.

Yarburgh Yarburgh. He improved the mid-nineteenth-century house and gardens, and constructed a large conservatory, the orangery, a clock tower, and a gatehouse. On the edge of the estate, he had a church built and a school designed by Sir Gilbert Scott. Dying at the age of seventy in 1876, Sewerby passed to his sister Alicia Maria, wife of George Lloyd of Stockton Hall, Stockton-on-the-Forest, York. Subsequently, the estate went to their younger son, the Revd Yarburgh Gamaliel Lloyd, a Lincolnshire vicar. He changed his name to Lloyd-Greame and his son, Col Yarburgh George Lloyd-Greame, inherited in 1890. The last of the line to inherit Sewerby was the colonel's elder son, another Yarburgh Lloyd-Greame, when, in 1934, he sold the house and part of the estate to Bridlington Corporation.

With a new lease of life, the hall and park opened to the public with a ceremony on 1 June 1936 by Hull-born aviator Amy Johnson. The site proved popular with visitors and locals alike and recently benefitted from a major improvement scheme with support from the Heritage Lottery.

Burton Agnes Hall

Burton Agnes Hall is a wonderful Elizabethan manor house in Burton Agnes village. Built by Sir Henry Griffith from 1601 to 1610, the design was by Robert Smythson. The present hall is close to the site of an older Norman Burton Agnes Manor House constructed around 1173, and still present adjacent to the Elizabethan house. Both structures are Grade I listed buildings, and, remarkably, the estate has been in same family since Roger de Stuteville built the first manor house. Of Welsh descent, Sir Walter Griffith resided here from 1457, his family having moved to Staffordshire in the thirteenth century before inheriting Burton Agnes. Sir Henry Griffith, was 1st Baronet, and constructed the hall after being appointed to the Council of the North, the administrative body set up in 1472 by the first Yorkist monarch, King Edward IV. Henry's daughter, Frances Griffith, inherited the estate and married Sir Matthew Boynton, Governor of Scarborough Castle and baronet. In 1634, the estate passed to their son Francis, who later became the second Baronet Boynton. Legend has it that the skull of Anne, Sir Henry's youngest daughter, is bricked up in the Great Hall – a 'screaming skull', which returns to the house if it is ever removed.

By the nineteenth century, the family experienced setbacks when the widow of the 6th Baronet remarried around 1784, and chose as her husband John Parkhurst of Catesby Abbey in Northamptonshire. Nicknamed 'Handsome Jack', he neglected the estate and lost much of the family fortune, dying in 1823. With the death of the 11th Baronet in 1899, the hall passed to his daughter, already married to Thomas Lamplugh Wickham, with the additional adopted surname of Boynton. On her death, the estate went to their son, Sir Marcus Wickham Boynton, and he ran a successful stud farm on the estate, becoming High Sheriff of Yorkshire from 1953 to 1954. Dying in 1989, the property was left to a distant cousin, twelve-year-old Simon Cunliffe-Lister, grandson of Viscount Whitelaw, son of the 3rd Earl of Swinton. Now managed by Cunliffe-Lister and his mother, Hon. Susan Whitelaw, the estate is today owned by the Burton Agnes Preservation Trust.

With careful restoration and conservation throughout the later twentieth century, the hall has fine seventeenth-century plaster ceilings and chimneypieces. There is the stunning Long Gallery with a beautiful ceiling restored by Francis Johnson between 1951 and 1974. The main façade is a storey higher than the rest of the building in order to house this gallery. Two square projecting bays flank the central double bay. The main rooms vary in size due to the recessions of the bay windows and the main feature of the interior is the Long Gallery, running the length of the main front. It is covered by a wagon-roofed, richly plastered ceiling. The 'great chamber', now split in two, was on the first floor above the parlour. Despite changes over the years, the hall retains many seventeenth-century features including carved woodwork, plaster, and alabaster. The original designs of the

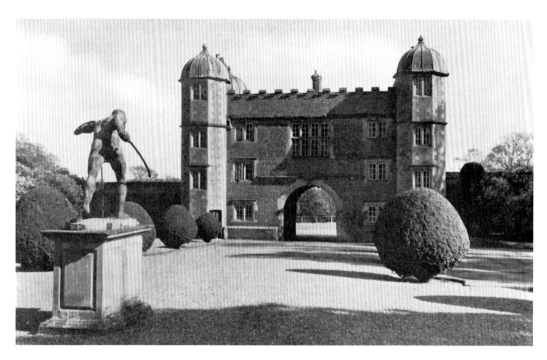

The gatehouse at Burton Agnes Hall in the mid-twentieth century.

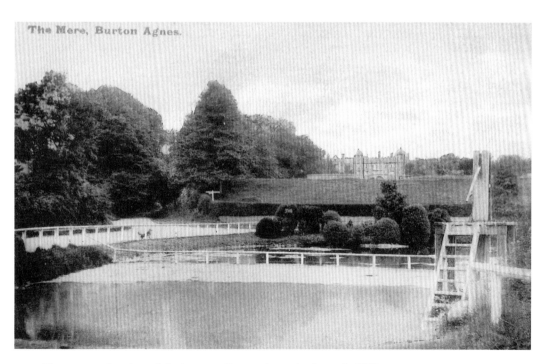

The mere and a view of the house at Burton Agnes in the early 1900s.

house were strongly influenced by Robert Smythson, though what was actually constructed probably varied with the builders themselves and the instructions of Sir Henry Griffith, who oversaw the work in person. Other features have been altered over the centuries, but Burton Agnes remains one of the most authentic houses of its type and well worth visiting.

The hall has pleasant gardens with over 3,000 plant species and varieties, the woodland walk being noted for February snowdrops. The gardens include games themes such as chess players, with statues and art works including changing displays by contemporary artists and sculptors. The Elizabethan hall and the old manor house are open to visitors throughout the year.

From Chalk Cliffs to Soft Boulder Clay & Dunes
From Sewerby to the south the landscape falls from the high chalk cliffs, to low-lying clay and sand dunes. The wetlands have mostly gone, lost to the drainage engineer and the farmer, and the sea is constantly eroding what remains. However, to walk the seashore here is an experience, which, while not so spectacular as the great cliffs, is wild in its own way.

Birds & Wildlife of the Seashore
The lower coastline lacks the amazing seabird cities but Bridlington Bay harbours flocks of gulls, kittiwakes, skuas, auks, sea ducks and more. Along the coastal zone of the beach and the dunes, wading birds scurry at the waves' edge, while terns scream and dive after small fish. Pools and dunes just inland provide habitat for wild flowers, for summertime butterflies and dragonflies, and for birds too.

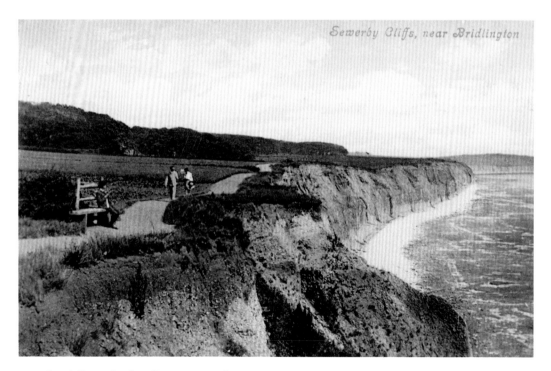

Sewerby Cliffs north of Bridlington around 1907.

Beside the Seaside in Skipsea, Hornsea & Withernsea

The once distinctive landscape of medieval settlements has been transformed beyond recognition, yet the evidence is there if we look. The great wetland has been reduced to ancient relics of Hornsea and a handful of small fragments. Much of Hornsea and of Withernsea already lies under the North Sea, joining dozens of other small towns and villages down the centuries. The massive Skipsea Castle motte-and-bailey is under greater threat today from coastal erosion than from marauding locals. As tourism dwindled, the now sleepy seaside residential town of Hornsea is popular to live and still a day visitor destination.

Skipsea

Skipsea is on the B1242 road at its junction with the B1249, around 10 miles (16 km) south of Bridlington, and 6 miles (10 km) north of Hornsea.

> From a casual glance at Skipsea no one would attribute any importance to it in the past. It was, nevertheless, the chief place in the lordship of Holderness in Norman times, and from that we may also infer that it was the most well-defended stronghold. On a level plain having practically no defensible sites, great earthworks would be necessary, and these we find at Skipsea Brough. There is a high mound surrounded by a ditch, and a segment of the great outer circle of defences exists on the south-west side. No masonry of any description can be seen on the grass-covered embankment, but on the artificial hillock, once crowned, it is surmised, by a Norman keep, there is one small piece of stonework. These earthworks have been considered Saxon, but later opinion labels them post-Conquest. In the time of the Domesday Survey the Seigniory of Holderness was held by Drogo de Bevere, a Flemish adventurer who joined in the Norman invasion of England and received his extensive fief from the Conqueror. He also was given the King's niece in marriage as a mark of special favour; but having for some reason seen fit to poison her, he fled from England, it is said, during the last few months of William's reign. The Barony of Holderness was forfeited, but Drogo was never captured.
>
> Gordon Home, *Yorkshire* (1908)

In Skipsea Brough, just west of the village, is Skipsea Castle, the major Norman fortification constructed 1086, with typical motte-and-bailey. While above-ground structures have gone, the impressive earthworks still stand. The first known use of the name Skipsea (Scandinavian origin) was twelfth-century, though the site was inhabited well before then. Prior to the Norman Conquest, this Yorkshire coast was vulnerable to Viking marauders, and Skipsea may be a Viking name for 'Ship Lake' or 'a lake navigable by ships'. This derives from the settlement's original location on the edge of a lake, suitable for navigation and eel fishing. This was over a 1,000 years ago with the sea much further away. With

land lost because of erosion, Skipsea today is a seaside village. Settlement goes back to the Stone Age and Bronze Age with building platforms revealed by nineteenth-century archaeological excavations. By AD 1160 to 1175, the borough was recorded as Skipsea Castle, probably founded by William le Gros, Count of Aumale (*d*. 1179).

By the late eleventh century, the village gained both Skipsea Castle and a church, thus encouraging the growth of a small town. According to the *Victoria County History*, during the thirteenth and fourteenth centuries, local markets and fairs were granted 'variously for Skipsea town, Skipsea manor, and Skipsea Brough manor, presumably all the same and possibly by then meaning Skipsea village'. The parish church is All Saints, designated a Grade I listed building in 1966.

A less positive claim to fame was that the Skipsea was shortlisted as a possible site for 1950s nuclear testing. However, and fortunately for the village, scientists at Aldermaston relented after vociferous local opposition. However, the Royal Observer Corps used Skipsea as a site for a Cold War observation post, active from October 1959 until decommissioned in September 1991. The site lay derelict but was discovered by an enthusiast in 2008.

With around 1,000 residents, the village economy is agriculture and tourism. The main attractions are the church, the spectacular castle, and proximity to the sea.

Skipsea Castle

Skipsea Castle was constructed around AD 1086, the residence and administrative centre of the Lords of Holderness. Situated in northern England on the vulnerable east coast, this was a potential problem region for William the Conqueror. In response, he created the Lordship of Holderness, the newly crowned king needing a trusted follower to control the area and adjacent coastline. The estate covered a vast landscape from the Humber Estuary

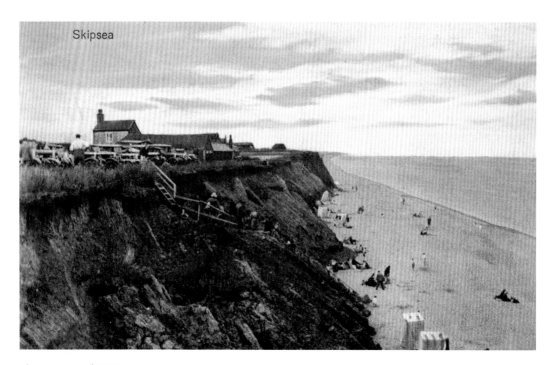

Skipsea around 1931.

to old Bridlington and William gave it to Drogo de la Beauvriére, a knight who fought alongside him at the Battle of Hastings. Drogo built Skipsea Castle as his main residence and then his successors, the Counts of Aumale, held the seat for 130 years. During the twelfth century, Count William le Gros established a fortified settlement or 'borough', probably located on the ridge. With houses and shops fronting onto the roadway, tolls and rents from the highway provided a steady income.

By the thirteenth century, the castle declined in importance as the Lords of Holderness moved their administrative residence to Burstwick. By this time, William de Forz, 3rd Earl of Albemarle (*d.* 1242) was the incumbent lord, described by William Stubbs as 'a feudal adventurer of the worst type'. He was involved both with and against King John as the tides of fortune ebbed and flowed. Skipsea was eventually destroyed in 1221 when Count William rebelled against King Henry III. By 1350, the borough abandoned, the castle grounds were leased for pasture and the Mere was drained in the early 1700s.

Motte-and-bailey castles of this type are not rare in England but the characteristic conical motte at Skipsea is exceptionally large. This is in part an illusion resulting from its location on a natural mound of glacial boulder clay. While the marshy ground surrounding the motte is natural, research suggests an earth dam (probably from the same period as the castle) was added to trap more water. The result was Skipsea Mere, a large, shallow lake serving as an ornament, fishpond, and defensive feature. The motte-and-bailey structure would have been vulnerable to attack from the nearby higher ground. To guard against this, the defended borough Skipsea Brough was built enclosed in massive earth ramparts encircling the main through-route down to the easiest crossing of the marshy ground. The castle and borough reflected the perceived importance of Skipsea in post-Conquest England. As time passed, the location was not enough to support the town, castle, and small port the lords tried to develop.

> Poulson, the historian of Holderness, states that Henry III. gave orders for the destruction of Skipsea Castle about 1220, the Earl of Albemarle, its owner at that time, having been in rebellion. When Edward II. ascended the throne, he recalled his profligate companion Piers Gaveston, and besides creating him Baron of Wallingford and Earl of Cornwall, he presented this ill-chosen favourite with the great Seigniory of Holderness.
>
> Gordon Home, *Yorkshire* (1908)

I mention more of the consequences of this for Scarborough in my companion volume *Yorkshire's Dinosaur Coast* (2014).

Skipsea Castle is a wonderful site, though not to everyone's taste. I recall many years ago witnessing a small boy distraught, as his expectations of the 'castle' were clearly something like Conway or Harlech, whereas today Skipsea is a large mound of earth. He was inconsolable.

Hornsea

There are several useful guides to the history and people of Hornsea, now the most significant settlement of the middle part of the Holderness coast. One of the larger seaside towns on the Holderness coast, Hornsea has around 8,500 residents. However, as recently as the early nineteenth century, according to the national census of 1801, Hornsea, or Hornsea-with-Burton, was a small settlement of only 533. The location was primarily agricultural though the market had declined. Despite this, Hornsea had two fairs taking place on 13 August and 17 December each year. This was together with a hiring fair for farm servants on the first Monday after Martinmas Day (11 November).

Going southwards from Skipsea, we pass through Atwick, with a cross on a large base in the centre of the village, and two miles further on come to Hornsea, an old-fashioned little town standing between the sea and the Mere. This beautiful sheet of fresh water comes as a surprise to the stranger, for no one but a geologist expects to discover a lake in a perfectly level country where only tidal creeks are usually to be found.

Gordon Home, *Yorkshire* (1908)

The growing popularity of sea bathing from the late eighteenth century generated some growth of Hornsea as a 'watering place', and it began to attract middle-class visitors. It was when the railway line from Hull reached Hornsea in 1864 that the place was transformed. It was now possible to reach Hull in around 45 minutes, making Hornsea attractive as a place for middle-class commuters to live, and vice versa, as a seaside destination for Hull residents. Hornsea even had a pier, which opened in 1880, but it lasted only seventeen years after being badly damaged by a ship shortly after opening and being demolished in 1897. Around 64 miles off the shore there will soon be a huge wind farm, scheduled to open around 2020, generating 1,200 MW of electricity; whether this will be good or bad for tourism, only time will tell.

Increasing population created commercial opportunities for shopkeepers and others. Indeed, by the late nineteenth century, there were twenty shops in Southgate, fifteen in the market place, and twenty in Newbegin. By the 1970s, Hornsea was famous for its hugely popular pottery factory, Hornsea Pottery. Sadly, this closed in 2000, and today, the world's largest display of the pottery is at Hornsea Museum in Newbegin, the town's main street. This also has local history exhibits and displays. Across from the museum is Bettison's Folly, a tower built by a local nineteenth-century businessman and boasting England's only fully working retractable flag pole. The church of Saint Nicholas is a Grade I listed building. Again, on the southern side of the town and close to the site of former pottery, adapting the original theme-park idea, begun in the heyday of Hornsea Pottery, is a large retail centre, Hornsea Freeport.

Public education began in Hornsea in 1845 with the Hornsea National School on Mereside. In 1901, with around 180 pupils, the school had space for 200. The school leaving age had risen to twelve years in 1899, though children working in agriculture could leave at eleven. In 1845, an infant school was built at Wassand Hall with room for 100 children and attendance averaging about 72.

Hornsea has many coastal defences such as sea walls, groynes and beach nourishment. However, despite these defences, Hornsea's primarily cliff-based shoreline of glacial boulder clay is eroding at one of the fastest known rates in Europe. Coastal erosion is very bad at either end of the main esplanade, where the hard defences end. In common with other resorts in the area (such as Withernsea, Bridlington, Filey and Scarborough), the town has a promenade with shops selling fish and chips, ice cream, bucket and spade sets, postcards, candyfloss, and other traditional seaside paraphernalia. This is along with a limited number of playground and fairground attractions, amusements, and one-armed bandits. Hornsea has an independent lifeboat service provided by Hornsea Rescue, a registered charity since 1994.

One of the town's main features is Hornsea Mere, a large lake and former RSPB bird reserve, which lies near the town and is popular for sailing. Hornsea Mere, the largest natural lake in Yorkshire, was created by glacial action during the last glaciations. The Yorkshire Wildlife Trust and the Strickland Constable Estate at Wassand Hall now promote it as a wildlife-viewing site.

From 1864 to 1964 (i.e. until the Beeching cuts), Hornsea had two railway stations, Hornsea Bridge and Hornsea Town, both served by the Hull & Hornsea Railway. In the 1860s, Joseph Armitage Wade, whose house was located where today the Hornsea School and Language College stands, opened the line. A cottage once frequented by

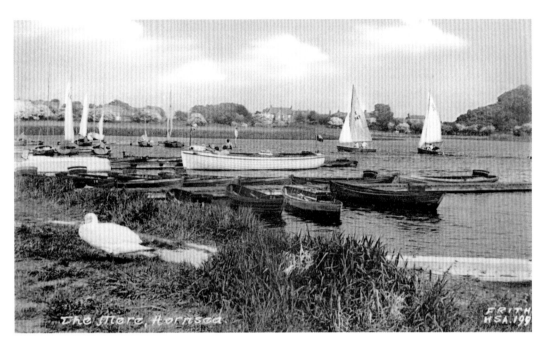

Hornsea Mere in the 1950s.

Hornsea Pottery in the 1980s.

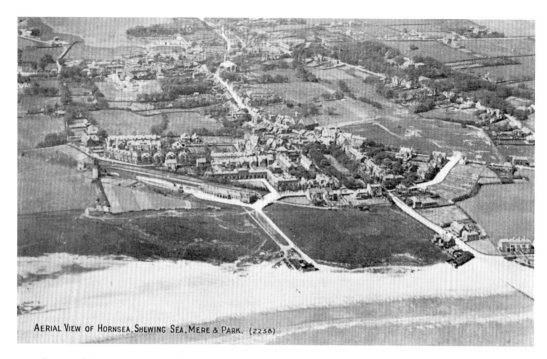

AERIAL VIEW OF HORNSEA, SHEWING SEA, MERE & PARK. (2256)

Aerial view of Hornsea showing the sea, the mere, and the park, early twentieth century.

Lawrence of Arabia and Winston Churchill (photographed in a house nearby) was close to the present-day school. After railway closure recommended by Richard Beeching in *The Reshaping of British Railways*, the disused line became the terminal section of the Trans Pennine Trail; the old railway line is now well maintained for walking and cycling.

Hornsea Parish Church

Hornsea has a pretty church with a picturesque tower built in between the western ends of the aisles. An eighteenth-century parish clerk utilized the crypt for storing smuggled goods, and was busily at work there on a stormy night in 1732, when a terrific blast of wind tore the roof off the church. The shock, we are told, brought on a paralytic seizure of which he died.

By the churchyard gate stands the old market-cross, recently set up in this new position and supplied with a modern head.

Gordon Home, *Yorkshire* (1908)

Hornsea Mere

Hornsea Mere was purchased by Marmaduke Constable of Wassand Hall in 1595 and it has remained in the family ever since. For a while in the 1980s, much of the mere was promoted as an RSPB Nature Reserve, but the relationship with owners seemed to sour and by the early 2000s, the site's connection to the RSPB was officially severed. Today, the Yorkshire Wildlife Trust is involved in partnership with the owners at Wassand Hall to promote parts of the mere as a nature reserve. The site has long been a popular recreational boating and sailing location too.

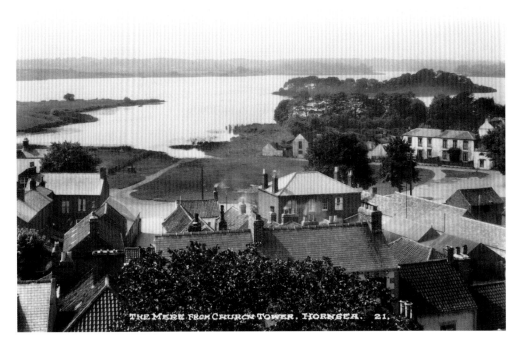

Hornsea Mere viewed from the top of the church tower, 1950s.

Hornsea Mere may eventually be reached by the sea, and yet that day is likely to be put further off year by year on account of the growth of a new town on the shore.

The scenery of the Mere is quietly beautiful. Where the road to Beverley skirts its margin there are glimpses of the shimmering surface seen through gaps in the trees that grow almost in the water, many of them having lost their balance and subsided into the lake, being supported in a horizontal position by their branches. The islands and the swampy margins form secure breeding-places for the countless water-fowl, and the lake abounds with pike, perch, eel, and roach.

It was the excellent supply of fish yielded by Hornsea Mere that led to a hot discussion between the neighbouring Abbey of Meaux and St. Mary's Abbey at York. In the year 1260 William, eleventh Abbot of Meaux, laid claim to fishing rights in the southern half of the lake, only to find his brother Abbot of York determined to resist the claim. The cloisters of the two abbeys must have buzzed with excitement over the impasse and relations became so strained that the only method of determining the issue was by each side agreeing to submit to the result of a judicial combat between champions selected by the two monasteries. Where the fight took place I do not know, and the number of champions is not mentioned in the record. It is stated that a horse was first swum across the lake, and stakes fixed to mark the limits of the claim. On the day appointed the combatants chosen by each abbot appeared properly accoutred, and they fought from morning until evening, when, at last, the men representing Meaux were beaten to the ground, and the York abbot retained the whole fishing rights of the Mere.

Gordon Home, *Yorkshire* (1908)

Wassand Hall & Gardens

The Strickland-Constable family of Wassand inherited the Hornsea estate including the mere after the direct Strickland line failed in 1938, but continuing a long-established family connection with Wassand Hall down the centuries. The hall is a fine Regency house in beautiful grounds on the B1244 road between Seaton and Hornsea. Owned and occupied by a single family since 1530, the estate has beautiful walled gardens, woodland and park walks, and glorious views of Hornsea Mere. The latter also belongs to the estate. The hall has collections of eighteenth- and nineteenth-century paintings and portraits of the former owners of Wassand Hall and their relatives. There are collections of English and European silver, furniture and porcelain from the same era. The house, gardens and parks are open on selected days during the summer, when teas are available in the fine conservatory in Wassand's beautifully planted walled gardens. Visitors to Wassand Hall can enjoy walks through the estate's beautiful parkland, a woodland walk from the car park, passing a small lake, an avenue of newly planted Norway maples, through paddocks into a small wood, and finally the Walled Garden. The half-mile walk takes visitors through wooded glades with views of the house and of Hornsea Mere.

A feature is the walled gardens, probably sixteenth-century, since parts of the wall are Tudor. The recently restored gardens supplied the main house with fresh vegetables, fruits, and flowers. The gardens around Wassand Hall have sweeping lawns with rose beds, lavender and herbaceous flowers, and views of Hornsea Mere, surrounding parkland, and farmland.

Gordon Home's *Yorkshire* (1908) notes earlier exploits of the Marmaduke Constables as recorded in the church at Flamborough:

> The altar-tomb of Sir Marmaduke Constable, of Flamborough, on the north side of the chancel, is remarkable for its long inscription, detailing the chief events in the life of this great man, who was considered one of the most eminent and potent persons in the county in the reign of Henry VIII. The greatness of the man is borne out first in a recital of his doughty deeds: of his passing over to France 'with Kyng Edwarde the fourth, y[t] noble knyght.
> And also with noble king Herre, the sevinth of that name
> He was also at Barwick at the winnyng of the same [1482]
> And by ky[n]g Edward chosy[n] Captey[n] there first of anyone
> And rewllid and governid ther his tyme without blame
> But for all that, as ye se, he lieth under this stone.'

The inscription goes on in this way to tell how he fought at Flodden Field when he was seventy, 'nothyng hedyng his age.'

Sir Marmaduke's daughter Catherine was married to Sir Roger Cholmley, called 'the Great Black Knight of the North,' who was the first of his family to settle in Yorkshire, and also fought at Flodden, receiving his knighthood after that signal victory over the Scots.

Forgotten Wartime History

All along the Viking Coast, there is evidence of past use in times of conflict, from Roman lookout stations to wartime anti-tank structures and pillboxes. However, like Lincolnshire to the south, there was another important function of the flatlands and even the meres of Holderness, for airfields during the First and Second World Wars. Geoffrey Simmons describes the First World War sites in his well-illustrated book from 2009, and Joe Gelsthorpe tells a remarkable story that centres on Killingholme and Hornsea, or, more precisely, Hornsea Mere. In fact, the mere was used for displays of flying boats or hydroplanes prior to the outbreak of war. Then, with the eruption of conflict imminent in

Wassand Hall, Hornsea, 1959.

1914, the Royal Naval Air service established a station at Killingholme on the Lincolnshire coast of the Humber. The site operated conventional land planes, and also seaplanes and flying boats. In September 1914, a seaplane was deployed to Bridlington, but bombing raids by Zeppelins soon became a problem. A response was to begin the development of air bases across the East Riding, including a station at Hornsea Mere by around 1915 to 1916. The seaplane substation at Hornsea was operated under the command of Killingholme.

Hornsea's Famous People

Hornsea has played host to many famous visitors over the years, including Princess Anne when she opened the Leisure Centre, and Victorian novelist Charlotte Brontë, who made frequent visits to the Yorkshire coast.

Joseph Sheard, Mayor of Toronto from 1871 to 1872, was born in Hornsea in 1813.

Charlotte Brontë spent a short time in Hornsea when staying with a former nursemaid who resided at one of the houses in 'Swiss Terrace', No. 96 Newbegin.

J. R. R. Tolkien, the world-famous author of *The Lord of the Rings*, *The Hobbit* and other books, was in the Hornsea area for around eighteen months in the so-called 'Tolkien Triangle' of Hull in the west, Kilnsea in the south-east, and Hornsea in the north-east.

Actor and comedian Brian Rix spent eighteen in Hornsea as a child and a teenager, living in Eastgate with his parents, Herbert and Fanny. Their ashes are buried in the churchyard of St Nicholas church where, in 1949, Brian married Elspet Gray.

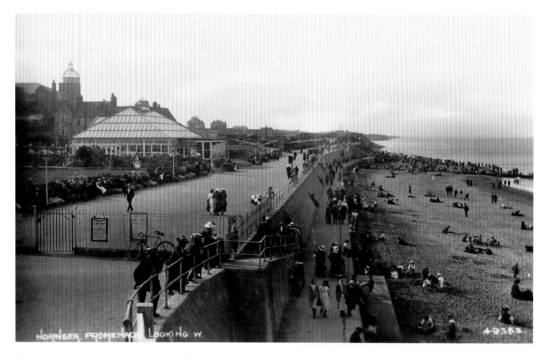

Hornsea Promenade and Floral Hall, maybe 1930s.

Actress Sheila Mercier starred as Annie Sugden, the owner of Emmerdale Farm, for its first twenty-five years. Sheila was the second daughter of Herbert and Fanny Rix, and sister of Brian, appearing in many of his farces at The Whitehall Theatre.

T. E. Lawrence (Lawrence of Arabia) was a regular visitor to his friend Wing Commander Sims at 'White Cottage', No. 3 Eastgate. Interestingly, Lawrence was for a short time connected with the running of the motorboats kept in readiness to rescue any aircraft crew forced to come down in the sea after practice bombing targets in the bay off Skipsea.

Winifred Holtby, English novelist and journalist, best known for her novel *South Riding*, lived for a while in Cliff Road.

Adrian Rawlins, the actor noted for playing Arthur Kidd in *The Woman in Black* (1989) and James Potter in the Harry Potter films, lives in Hornsea.

Johnny Briggs, former England cricketer born in 1862, played for Hornsea CC.

Aldbrough

Aldbrough lies around 12 miles (19 km) north-east of Hull at the junction of the B1242 and B1238 roads, with the village itself and hamlets of East Newton, Etherdwick and Tansterne. It has a little over 1,000 residents. The pretty church of St Bartholomew is a Grade II* listed building. Historically there was a hamlet at Ringbrough (or Ringborough) from at least the eleventh century, but in all likelihood well before that. In 1823, Aldbrough was a parish in the Wapentake and Liberty of Holderness, with a population of 998, including

the townships of East and West Newton. Occupations included fourteen farmers, two blacksmiths (one of whom was a farrier), a joiner (also an auctioneer), four wheelwrights, four grocers, five shoemakers, four tailors, two butchers, a hairdresser, a common brewer and the landlords of The George and The Bricklayer's Arms public houses. There were also the parish vicar and curate, three yeomen, two schoolmasters, two surgeons, a bailiff, an excise officer, a gentleman and a gentlewoman. Five carriers operated between Aldbrough and Hull twice weekly. The settlement of Fosham was 1 mile (1.6 km) to the south-east and included in Aldbrough. Fosham had two farmers and a once-a-week carrier to Hull, but by the 1850s, coastal erosion reduced this to a single farm. However, in the 1940s, Aldbrough expanded as a Second World War military base, with gun emplacements, lookouts, and underground bunkers. Today coastal erosion still takes its toll.

Withernsea

Withernsea, the focal point for a wider community of small villages in this part of Holderness, is one of the larger coastal settlements with around 6,000 residents. The most famous landmark is the white inland lighthouse, rising some 127 feet (39 metres) above Hull Road. This has now become a museum dedicated to 1950s actress Kay Kendall, who was born here. Withernsea's most significant boast is invisible, as the Prime Meridian crosses the coast just to the north-west. Like many similar seaside towns, Withernsea has a wide promenade north and south. This runs from the striking pier towers, constructed in 1877 at a cost of £12,000 as the entrance to the pier. The latter was originally 399 yards (365 metres) long, but gradually shortened due to collisions from local ships, including the *Saffron* in 1880, an unnamed ship in 1888, a Grimsby fishing boat and then the *Henry Parr* in 1893. This left the once grand pier with a mere 50 feet (15 metres) of damaged wood and steel, removed in 1903. However, the refurbished pier towers stand as a proud memorial to the lost structure.

ST *Ostrich* aground at Aldborough, 12 February 1912.

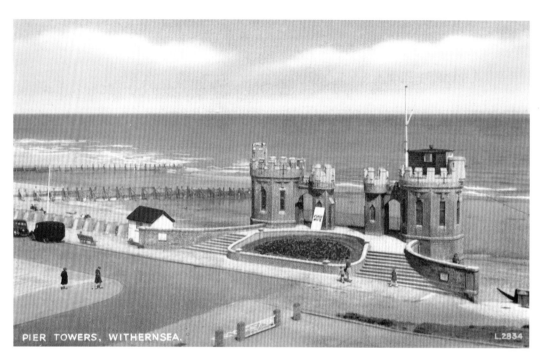

The Pier Towers on the front at Withernsea, mid-twentieth century.

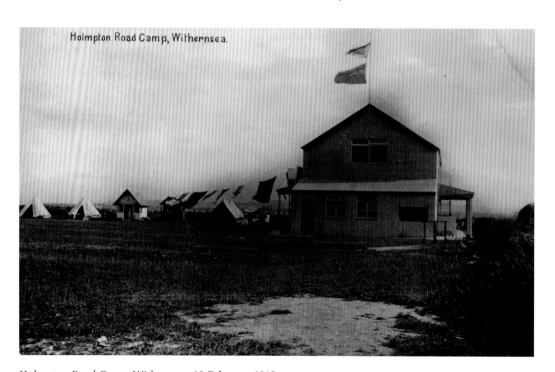

Holmpton Road Camp, Withernsea, 19 February 1918.

During the mid-nineteenth century, the Hull & Holderness Railway connected the nearby Hull with Withernsea (via Keyingham and Patrington), making possible cheap and convenient holidays for Victorian workers and their families, and boosting Withernsea's economy. However, the railway closed in 1964 and all that remains is an overgrown footpath where the track used to be. Withernsea, like many British resorts, has suffered from a decline in the number of visiting holidaymakers. Withernsea's better-known tourist attractions and landmarks include the lighthouse situated on Hull Road with a museum dedicated to actress Kay Kendall; the pier towers overlooking the beach; Valley Gardens with the outdoor events arena; amusement arcades or 'muggies'; the RNLI lifeboat museum; the parish church of St Nicholas; and proximity to the Greenwich Meridian.

The busy town of Hornsea Beck, the port of Hornsea, with its harbour and pier, its houses, and all pertaining to it, has entirely disappeared since the time of James I., and so also has the place called Hornsea Burton, where in 1334 Meaux Abbey held twenty-seven acres of arable land. At the end of that century not one of those acres remained. The fate of Owthorne, a village once existing not far from Withernsea, is pathetic. The churchyard was steadily destroyed, until 1816, when in a great storm the waves undermined the foundations of the eastern end of the church, so that the walls collapsed with a roar and a cloud of dust.

Twenty-two years later there was scarcely a fragment of even the churchyard left, and in 1844, the Vicarage and the remaining houses were absorbed, and Owthorne was wiped off the map.

Gordon Home, *Yorkshire* (1908)

Low Cliffs and Sandy Beaches

By Hornsea and Withernsea, the tall chalk cliffs are a distant memory and here the crumbling boulder clay holds sway. The beaches mix sand and pebbles or shingle in variable amounts, and largely, farming or urban development with its concrete sea walls, encroach right to the brink of the collapsing cliffs.

Wildlife and Birds of Coast and Mere

The cliffs are a wonderful habitat for one of our earliest summer visitors, the delicate sand martin. All along the coastline, the cliffs are peppered with nest holes of the sand martin colonies. The seashore provides opportunities for the usual seaside species and for viewing migrants out at sea. Where there is scrub along the top of the cliffs, migrant warblers descend for rest and shelter. Noisy flocks of house sparrows and sometimes tree sparrows also gather in dense bushes and shrubs. Birds of open farmland such as lapwings and rooks can be seen in good numbers, and migrating thrushes and starlings arrive as if by magic, skimming low over the waves.

The wildlife gem of this region is by far and away Hornsea Mere, with its ducks and rare grebes, its flocks of migrating swallows, martins and swifts, and occasionally attendant hobbies. The mere attracts black terns and little gulls in August and September.

Roos church near Withernsea, around 1907.

Ellison's Entertainers at Withernsea in 1912.

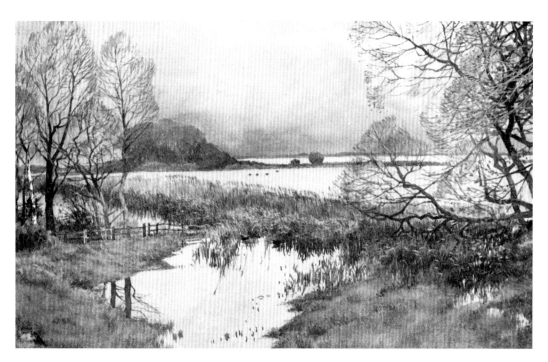

Hornsea Mere from Gordon Home, 1908.

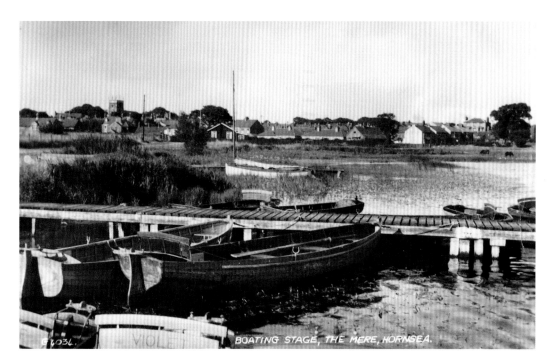

Boating stage, The Mere, Hornsea around 1952.

The Landscape & People of the Southern Holderness Coast – From Spurn Point to Kingston-upon-Hull

Along to the Humber

> Away with me in post to Ravenspurgh;
> But if you faint, as fearing to do so,
> Stay and be secret, and myself will go.

Shakespeare, *Richard II*, act II, scene 1

Kingston-upon-Hull has long been a major centre with trade to Europe and the once-proud fishing industry made it a nationally important city. The now post-industrial city is rapidly regenerating, coastal transport is still important, and Hull a significant university city. South of Hull is the stunning Humber Bridge, gateway to Lincolnshire and beyond. Eastward is the bleak, exposed Spurn Point or Spurn Head, an ancient yet mobile spit of sand extending far out into the mouth of the great Humber Estuary. Today this is an internationally important conservation site famed for its rare migrant and passage birds.

> As we go towards Spurn Head we are more and more impressed with the desolate character of the shore. The tide may be out, and only puny waves tumbling on the wet sand, and yet it is impossible to refrain from feeling that the very peacefulness of the scene is sinister, and the waters are merely digesting their last meal of boulder-clay before satisfying a fresh appetite
>
> The peninsula formed by the Humber is becoming more and more attenuated, and the pretty village of Easington is being brought nearer to the sea, winter by winter. Close to the church, Easington has been fortunate in preserving its fourteenth-century tithe-barn covered with a thatched roof. The interior has that wonderfully imposing effect given by huge posts and beams suggesting a wooden cathedral.
>
> At Kilnsea the weak bank of earth forming the only resistance to the waves has been repeatedly swept away and hundreds of acres flooded with salt water, and where there are any cliffs at all, they are often not more than fifteen feet high.

Gordon Home, *Yorkshire* (1908)

The Humber Estuary forms a vast artery draining much of middle England and forming a huge barrier between Lincolnshire to the south and Yorkshire on the northern shore. However, while it is a barrier in one sense, the river has been a conduit to and from Europe since prehistoric times, and continues to be so today.

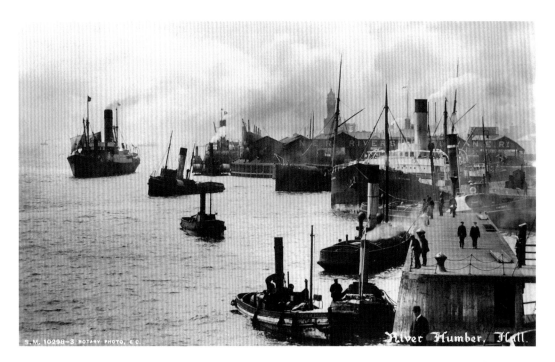

The River Humber at Hull, 1920s.

Easington & Spurn Head

When Henry of Lancaster landed with his retinue in 1399 within Spurn Head, the whole scene was one of complete desolation, and the only incident recorded is his meeting with a hermit named Matthew Danthorp, who was at the time building a chapel.

Gordon Home, *Yorkshire* (1908)

Today, Easington is the location for the large natural gas, Easington Gas Terminal, with processing and storage offshore, and the Norway to UK 'Langeled pipeline'. However, in 1823 this was a small but thriving community of 488 residents including a butcher, a corn miller, a weaver, two blacksmiths, two wheelwrights, two grocers, three shoemakers, four tailors, twelve farmers, two schoolmasters, a land surveyor, a yeoman, the landlord of the Granby's Head public house, and two carriers operating between Easington and Hull. Since then much of the village has been lost to the ravages of the North Sea.

Spurn Point (or Spurn Head) in Easington is a narrow sand spit on the south-eastern tip of the coast extending out into the North Sea to form the north bank of the mouth of the Humber Estuary. The headland is over 3 miles (4.8 km) long (about half the width of the estuary at that point), and in parts is only 50 yards (46 metres) wide – sometimes less, if the sea has washed a section away. Owned since 1960 by the Yorkshire Naturalists' Trust (now Yorkshire Wildlife Trust), the headland covers 280 acres (113 hectares) above high water plus 450 acres (181 hectares) of foreshore, has an RNLI lifeboat station and a disused lighthouse. It is a National Nature Reserve, designated Heritage Coast, and is part of the Humber Flats, Marshes and Coast Special Protection Area.

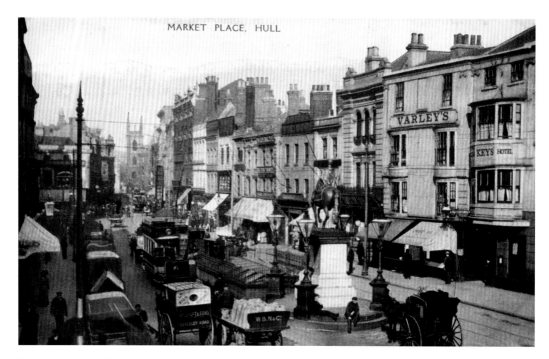

The marketplace, Hull, in the early 1900s.

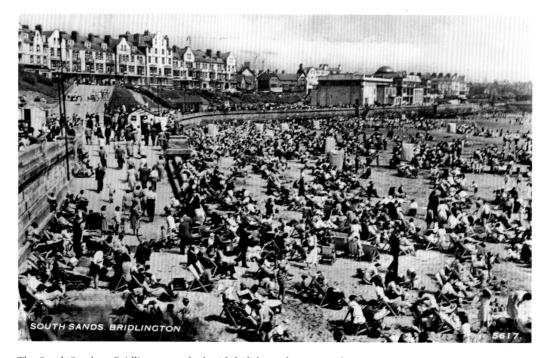

The South Sands at Bridlington packed with holidaymakers, posted in 1950.

High Street Easington, early 1900s.

Far back in the Middle Ages the Humber was a busy waterway for shipping, where merchant vessels were constantly coming and going, bearing away the wool of Holderness and bringing in foreign goods, which the Humber towns were eager to buy. This traffic soon demonstrated the need of some light on the point of land where the estuary joined the sea, and in 1428 Henry VI granted a toll on all vessels entering the Humber in aid of the first lighthouse put up about that time by a benevolent hermit.

No doubt the site of this early structure has long ago been submerged. The same fate came upon the two lights erected on Kilnsea Common by Justinian Angell, a London merchant, who received a patent from Charles II to 'continue, renew, and maintain' two lights at Spurn Point.

Gordon Home, *Yorkshire* (1908)

The earliest reference to a lighthouse on Spurn Point is 1427, but from the seventeenth century, there are two lighthouses: a high light and a low light. In 1767, the engineer John Smeaton was commissioned to build a new pair of lighthouses, and his high light (a 90-foot tower) was in use until 1895. However, there were problems maintaining the low light that had in a short time, been washed away by the sea. Various replacements were used throughout the early 1800s, until in 1852 a more solid lighthouse was constructed.

Gordon Home explains that,

In 1766 the famous John Smeaton was called upon to put up two lighthouses, one 90 feet and the other 50 feet high. There was no hurry in completing the work, for the foundations of the high light were not completed until six years later. The sea repeatedly destroyed the low light, owing to the waves reaching it at high tide. Poulson mentions the

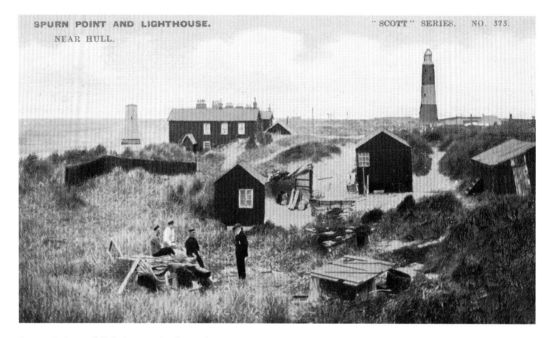

SPURN POINT AND LIGHTHOUSE. " SCOTT " SERIES. NO. 373.
NEAR HULL.

Spurn Point and lighthouses in the early 1900s.

loss of three structures between 1776 and 1816. The fourth was taken down after a brief life of fourteen years, the sea having laid the foundations bare. As late as the beginning of last century the illumination was produced by 'a naked coal fire, unprotected from the wind,' and its power was consequently most uncertain.

Smeaton's high tower is now only represented by its foundations and the circular wall surrounding them, which acts as a convenient shelter from wind and sand for the low houses of the men who are stationed there for the lifeboat and other purposes.

By 1895, a single lighthouse replaced both lights and this stands to the present day on the relatively stable grassland of Spurn Head. The 1852 'low light' remains on the shore of the sandy spit, but its lamp replaced by a large water tank. Today, only the foundations of Smeaton's old 'high light' remain, the present-day lighthouse, a round brick tower, 128 feet high, painted black and white, was built in 1895 designed by Thomas Matthews. The beam reaches out 17 nautical miles. Other lights marked particular shoals or sandbanks, and the main channel along the Humber, always a problem for shipping because of the tendency for sands shifting suddenly and dramatically. Modern navigational aids make the lights largely redundant, but the empty lighthouse has a new lease of life as a visitor centre for the Yorkshire Wildlife Trust.

Located in the estuary on shifting sands, the headland has a chequered history of destruction and rebirth over centuries. Furthermore, with its strategically significant position at the mouth of one of England's greatest arterial routes from Europe, the site has a rich history beyond its remote location. In the Middle Ages, Spurn had the port of Ravenspurn (Ravenspur or Ravensburgh) where, in 1399, Henry Bolingbroke landed on his return to dethrone Richard II. It was here too that Sir Martin De La See led local resistance against Edward IV's landing on 14 March 1471, Edward returning from six months' exile in

the Netherlands. Spurn had earlier settlements such as the village of Ravenser Odd located further out, and along with Ravenspurn lost to the sea, as Spurn Head, as the sand spit migrated westwards over the centuries.

> The story of Ravenser, and the later town of Ravenserodd, is told in a number of early records, and from them we can see clearly what happened in this corner of Yorkshire. Owing to a natural confusion from the many different spellings of the two places, the fate of the prosperous port of Ravenserodd has been lost in a haze of misconception. And this might have continued if Mr. J. R. Boyle had not gone exhaustively into the matter, bringing together all the references to the Ravensers which have been discovered.
> There seems little doubt that the first place called Ravenser was a Danish settlement just within the Spurn Point, the name being a compound of the raven of the Danish standard, and eyr or ore, meaning a narrow strip of land between two waters. In an early Icelandic saga the sailing of the defeated remnant of Harold Hardrada's army from Ravenser, after the defeat of the Norwegians at Stamford Bridge, is mentioned in the lines:
> The King the swift ships with the flood
> Set out, with the autumn approaching,
> And sailed from the port, called Hrafnseyrr (the raven tongue of land).

> Gordon Home, *Yorkshire* (1908)

Home explains the importance of the estuary in early times, something that continues to this day. He notes how, in the Middle Ages, great fortunes were made along the Humber shore. Significant local merchant Sir William de la Pole traded at Ravenserodd, and from his great

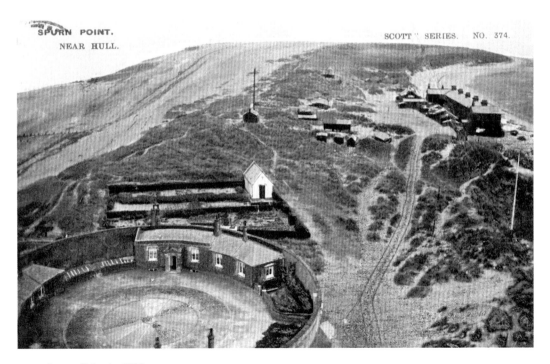

Spurn Point in 1907.

wealth, his son became knight bannerette, and his grandson Earl of Suffolk. Another De la Pole was the first Mayor of Hull – a wealthy man who lent large sums of money to Edward III. This led to his appointment as Chief Baron of the Exchequer and Lord of Holderness. By 1810, with busy coastal traffic, Spurn had a lifeboat station, and being a remote location, homes were built for the lifeboat crew and their families. The site remains one of the only lifeboat stations manned by full-time paid staff (the others are on the River Thames).

Significant in times of conflict, during the First World War, Spurn had two coastal artillery 9.2-inch (230-mm) gun batteries, with 4-inch (100-mm) and 4.7-inch (120-mm) quick-firing guns in between. Despite collapse due to erosion, along with a former railway, the ruins remain visible. The remnants of the railway come as a surprise to visitors but are described in detail by Kenneth Hartley in his 1976 article. It seems that the railway was built by the War Department to serve the gun emplacements and other defensive structures at the mouth of the Humber, was still operating with a petrol railcar in 1933, and survived most of the Second World War before being dismantled in 1951.

Spurn is a hugely important for wildlife, especially migrating birds. The landward-side mudflats are feeding grounds for wading birds, and a bird observatory with accommodation for visiting birdwatchers to monitor migrating birds. Easterly autumn winds aid migration, resulting in drift movements of Scandinavian and north European birds, with spectacular 'falls' of thousands of birds. These include typical seashore species, but large numbers of non-coastal migrants like warblers and thrushes too. Visitors include abundant common species and many rarities, including the North American cliff swallow, Siberian lanceolated warbler, and even black-browed albatross from the Southern oceans. Most likely, with a good fall, visitors will see wheatears, whinchats, common redstarts, robins, ring ouzels, blackbirds, fieldfares, and redwings in abundance. These birds shelter and refuel on their way between breeding and wintering grounds. With winds in the right direction, migrant birds are pushed down the narrow Spurn peninsula and 'visible migration' counts at Narrows Watchpoint can exceed 15,000 birds on a single autumn morning, with 3,000 birds a regular number. Out at sea, other birds pass through with mixed gulls, terns, skuas, auks, ducks, grebes, divers and gannets.

The headland has always been vulnerable to extreme high tides and storm events. It was badly affected by the December 2013 tidal surge, and access is restricted.

Patrington

> Patrington village is of fair size, with a wide street; and although lacking any individual houses calling for comment, it is a pleasant place, with the prevailing warm reds of roofs and walls to be found in all the Holderness towns.
>
> Gordon Home, *Yorkshire* (1908)

This small village, a seat of the ancient Hildyard/Hilliard/Hildegardis family, is on the A1033 road around 9 miles (14 km) south-east of Hedon and 4 miles (6.4 km) south-west of Withernsea. St Patrick's parish church, the 'Queen of Holderness', a Grade I listed building, with a spire around 190 feet high, is an excellent example of decorated Gothic architecture. The church was a navigational landmark and aid for sailors entering the Humber. Used for ground-controlled interception of incoming raids, RAF Patrington radar station was constructed during the Second World War. The original station closed following construction of RAF Holmpton station in 1955, later renamed RAF Patrington. From 1854 until closure in 1964, Patrington was on the Hull & Holderness Railway with its own station.

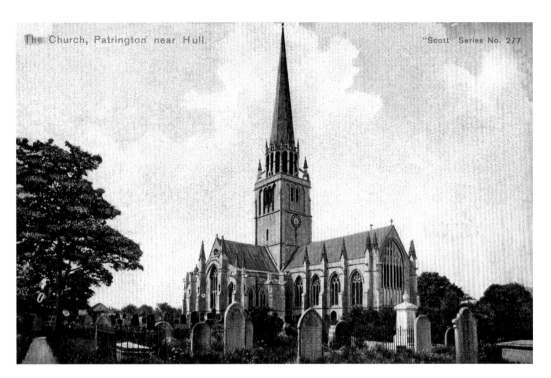

The Church, Patrington near Hull. "Scott" Series No. 277

Patrington church perhaps around the 1920s.

> The very beautiful spire of Patrington church guides us easily along a winding lane from Easington until the whole building shows over the meadows.
>
> Gordon Home, *Yorkshire* (1908)

Patrington Haven hamlet is a mile south-west of Patrington. Once served by a navigable creek from the Humber, it now boasts a holiday camp. The White Hall, Patrington, a Grade II listed building, is a small country house built in Greek Revival style attributed to John Nash for Arthur Maister in 1814/15. Another fine building, constructed for Dr Lands returning from overseas, the late Georgian and early Victorian Dunedin Country House offers up-market holiday accommodation in very pleasant surroundings. A workhouse once adjacent to the main house was demolished in 1981.

Kingston-upon-Hull

Hull is a major city with a long and often distinguished history. The interested reader should consult one of the many accounts of the area, such as Gillett & MacMahon's *A History of Hull* (1989). Gordon Home described the biggest city in Holderness a little before 1908.

> In approaching nearer to Hull, we soon find ourselves in the outer zone of its penumbra of smoke, with fields on each side of the road waiting for works and tall shafts, which will spread the unpleasant gloom of the city still further into the smiling country. The sun becomes copper-coloured, and the pure, transparent light natural to Holderness loses its vigour. Tall and slender chimneys emitting lazy coils of blackness stand in

pairs or in groups, with others beyond, indistinct behind a veil of steam and smoke, and at their feet grovels a confusion of buildings sending forth jets and mushrooms of steam at a thousand points. Hemmed in by this industrial belt and compact masses of cellular brickwork, where labour skilled and unskilled sleeps and rears its offspring, is the nucleus of the Royal borough of Kingston-upon-Hull, founded by Edward I at the close of the thirteenth century.

It would scarcely have been possible that any survivals of the Edwardian port could have been retained in the astonishing commercial development the city has witnessed, particularly in the last century; and Hull has only one old street which can lay claim to even the smallest suggestion of picturesqueness. The renaissance of English architecture is beginning to make itself felt in the chief streets, where some good buildings are taking the places of ugly fronts; and there are one or two more ambitious schemes of improvement bringing dignity into the city; but that, with the exception of two churches, is practically all.

Hull, or, more correctly, Kingston-upon-Hull, is the region's major city, with 256,000 residents. It lies on the River Hull where it joins the Humber. In the 1980s, a debate raged with Yorkshire Water Authority as to whether Hull was 'Hull on Sea', or 'Hull on Humber'. At the time, if it was the former, it was legal to pour raw, untreated sewage from the city into the North Sea. Thankfully, for all concerned, common sense (and later law) ruled Hull's effluent required proper treatment.

Hull was founded late in the twelfth century because the nearby Meaux Abbey monks required a port to export wool. Where the rivers Hull and Humber joined was ideal to build a quay, and while the exact date of Hull's foundation is unknown, by 1193 it was noted as Wyke on Hull. In 1299, King Edward I (Longshanks) renamed the place as Kings-town upon Hull, and on 1 April 1299, Edward granted the city's royal charter, now preserved in the Guildhall archives. J. C. Craggs (1817), in his *Guide to Hull*, gave a romanticised account of King Edward's relationship with the town, describing the Royal hunting party starting a hare that

> led them along the delightful banks of the River Hull to the hamlet of Wyke ... [Edward], charmed with the scene before him, viewed with delight the advantageous situation of this hitherto neglected and obscure corner. He foresaw it might become subservient both to render the kingdom more secure against foreign invasion, and at the same time greatly to enforce its commerce.

Charmed by the location, Edward purchased the land from the Abbot of Meaux, and built a manor house, where he issued proclamations to encourage further development and gave the prestigious royal appellation, 'King's Town'. Since then, Hull, first town and then city, has been a market town, military supply port, trading hub, fishing and whaling centre, and industrial metropolis. Historically important and significant, Hull was involved in wars and other issues; with a large arsenal and strategic location, the city was an early player in the English Civil War. On 11 January 1642, King Charles nominated the Earl of Newcastle as Governor of Hull, whereas Parliament appointed Sir John Hotham as governor. They requested that his son, Capt. John Hotham, take the town for Parliament, which meant Sir John Hotham and Hull Corporation declared for Parliament and refused Charles entry. The King's response was to lay siege, which triggered conflict between Parliamentary and Royalist forces.

Although there is little evidence of major early settlement around today's city, the Hull Valley was inhabited since early Neolithic times. Attractive to early settlers because excellent access to navigable rivers led to a prosperous hinterland, the remote, low-lying site without potable fresh

water was not good. In my 2010 book, *Yorkshire's Forgotten Fenlands*, I note how this problem persisted into the late medieval period, when,

> ... with Kingston upon Hull essentially an island surrounded by brackish water and shifting sands. The Julian Dyke and an aqueduct brought supplies of freshwater to the city, but this had collapsed by around 1507 and water had to be brought in by boat. As can be imagined, the excessive cost of this operation for such a basic commodity was a source of much consternation to the inhabitants.

The earliest named settlement was an outlier of Myton hamlet called Wyke, perhaps of Scandinavian origin from *Vik* or 'creek', or Saxon *Wic*, a dwelling place or refuge. The River Hull was good haven for shipping, trade developing from Meaux Abbey wool exports, and then many other goods imported and exported. In 1440, a second charter incorporated Hull with local government by mayor, sheriff, and twelve aldermen.

Hull was important to Edward as a base during the First War of Scottish Independence, later becoming the most important English east coast port. Exports of wool and woollen cloth, and imports of European wine and timber, brought prosperity. The town joined flourishing commercial connections with the Hanseatic League Baltic ports. From medieval times, Hull's major trade links were with Scotland and northern Europe; Scandinavia, the Baltic and the Low Countries became key destinations for Hull merchants. Trade also developed with France, Spain, and Portugal, and as steam replaced sail in the 1800s, trade expanded globally to include Australian, New Zealand and South American frozen meat. With purpose-built docks and facilities, Hull was the centre for commercial networks including inland and coastal trading across Britain.

The patron of Hull grammar school, Bishop John Alcock, was from a successful trading family and founded Jesus College, Cambridge. However, a less positive aspect of global trade was a particularly nasty outbreak of syphilis, apparently brought in from America with transatlantic connections following the discovery of the New World. This virulent English outbreak that occurred before Columbus was via Norwegian Icelanders and Greenlanders, and Norwegian sailors and merchants visiting the east coast ports of King's Lynn and Hull. The epidemic erupted across England, but with little impact elsewhere in Europe, and the outbreak died out. Other English towns affected included York, London, Gloucester and possibly Norwich.

Sixteenth- and seventeenth-century Hull prospered; well-appointed private and civic buildings like merchant's houses such as Blaydes House and surviving warehouses in the Old Town testify to affluence. Wilberforce House, for example, is now a museum about the life and work of William Wilberforce, its eighteenth-century MP, central in the abolition of the British slave trade. During the nineteenth century into the early twentieth, Hull was important for British and European settlers going to the Americas, often via Liverpool. Central to the global trade network, Thomas Wilson established the Wilson Line of passenger transportation in Hull in 1825. By the early 1900s, with over 100 vessels travelling the globe, it was the world's largest privately owned shipping company. Eventually, the Hull-based Ellerman Line owned by Britain's richest man at the time, Sir John Ellerman, bought out the Wilson Line. Economic prosperity peaked in the late Victorian period, and Hull gained city status in 1897.

Other influences on Hull and Holderness included whaling and fishing; as whaling declined, deep-sea cod fishing took over. The 1930s boom had seen Hull expand with new suburban areas to the west, as part of Britain's largest housing expansion with new garden city developments and slum clearances. Other industries included oilseed crushing. However, with the Anglo-Icelandic 'Cod War' of 1975/76, the agreements triggered a massive decline in Hull's fortunes. Previously affected badly by Second World War bombing (the Hull Blitz), after the Cod War, Hull experienced prolonged, post-industrial decline, associated social deprivation,

The Wilberforce Inn, Hull, 1800s.

and issues for education and policing. However, by the early twenty-first century, the city had spending and investment booms with new retail, commercial, housing, and public service construction. Trade centred on the River Hull, before moving to the Humber docks.

In recent times, tourism and leisure have increased and by 2009, 5 million visitors per year contributed £210 million to Hull's economy. Established attractions include the historic Old Town and Museum Quarter, Hull Marina and The Deep aquarium. The city boasts excellent hotels, theatres, major sporting clubs and facilities, and the Hull Marina (from the old Humber Street Dock). This opened in 1983 with facilities for 270 yachts and small sailing craft. A distinctive feature of Hull is the municipally owned telephone system dating from 1902, with cream, not red, telephone boxes. In November 2013, the announcement of Hull as the UK City of Culture for 2017 was a major boost to civic pride. Hull is still a busy port with 13 million tons of cargo annually, employing 5,000 people directly with 18,000 others associated with port activities. Introduction of 'roll-on roll-off' ferry services to continental Europe proved important with 1 million plus passengers annually. Today Hull's businesses deliver an annual turnover of almost £8 million. Modern Hull includes extensive and major retail outlets and a thriving leisure sector. Hull is the undoubted capital of Holderness and the Viking Coast.

Home (1908) lamented the loss of historic Hull, transformed by so many vicissitudes of economy and history.

When we see the old prints of the city surrounded by its wall defended with towers, and realize the numbers of curious buildings that filled the winding streets—the windmills, the churches and monasteries—we understand that the old Hull has gone almost as completely as Ravenserodd. It was in Hull that Michael, a son of Sir William de la Pole of Ravenserodd, its first Mayor, founded a monastery for thirteen Carthusian monks, and also built himself,

in 1379, a stately house in Lowgate opposite St. Mary's Church. Nothing remains of this great brick mansion, which was described as a palace, and lodged Henry VIII during his visit in 1540. Even St. Mary's Church has been so largely rebuilt and restored that its interest is much diminished. The great Perpendicular Church of Holy Trinity in the market-place is, therefore, the one real link between the modern city and the little town founded in the thirteenth century.

Famous People from Hull

Hull is too big and long-standing to list its famous sons and daughters in this short account. The most significant must include the Victorian MP William Wilberforce, instrumental in the abolition of slavery. In popular culture, Sheffield-born musician Paul Heaton has spent most of his life in Hull, as mentioned in songs by his band, The Beautiful South. There are many other musicians, but Mick Ronson, guitarist with David Bowie, is one of the most famous.

The Coventry-born poet Philip Larkin lived in Hull when the resident librarian at Hull University. The city boasts numerous actors including John Alderton, Ian Carmichael OBE, Maureen Lipman, Reece Shearsmith (a member of The League of Gentlemen), and many more.

Shifting Sands and Tidal Surges

Hull and Spurn remain some of the most vulnerable places in the world for flooding from sea and overland, and erosion from storm events and tidal surges. This is the Biblical house built on sand taken to an extreme.

Migrants, Vagrants and Wildlife on the Move

The estuary combines with the sandspit at the end of a long, sweeping coastline to provide a wonderful place to view wildlife. Beware, though, because this can be a bleak, icy location – and that is just in summer!

Sperm whale washed up at Bridlington, 1 January 1937, probably having become disorientated in the North Atlantic and then ending up in the bottleneck of the North Sea.

Lost Landscapes of the East Riding Coastline

Holderness stretches from the heights of the Yorkshire Wolds to the low clay cliffs and sandy beaches of the Viking shoreline. Since early times, this has been a landscape of people and farming, though for centuries, the poor quality of the higher ground and the wetness of the lower made agriculture difficult. Over the last two centuries, however, the agricultural 'improver' has swept away the old and turned much of the region to one of rich, fertile farming. Gone are the ancient rabbit warrens of the medieval wolds, or the duck decoys of the fens and carrs. Holderness has a remarkable heritage of early churches, of which Beverley minister is hugely important. Just beyond the built township of Beverley is also a unique area of still unenclosed common grazing land and this provides a dramatic view to the medieval churches. The town is surrounded by rich, rolling, farmed countryside that today is encroached on from the south by new housing. However, for the story of the Viking Coast, the issue here is not the inland changes, but coastline erosion by the North Sea. This creeping catastrophe for the Yorkshire folk of this coastal zone, with climate change and extreme weather, is getting worse. There is not space in this short account to do more than touch on the issues and consequences, but rest assured, it is serious. Historians and others have written about the phenomenon of the lost coastline here, and in 1912, Thomas Sheppard wrote a wonderfully rich account of *The Lost Towns of the Yorkshire Coast*. The interested reader should seek out and digest this volume.

Coastal Destruction

Sheppard noted that between 1848 and 1893, 774 acres of the Yorkshire coast were lost to the sea. Interestingly too, Sheppard notes that local accounts frequently enhance and exaggerate stories of destruction, and may be factually inaccurate. For example, a story published in 1906 stated the coastline here had two rocky promontories, Flamborough and Spurn Point, the latter being famously sandy! However, the Victorians set up an enquiry through the British Association for the Advancement of Science to consider issues of coastal erosion in England and Wales. For Holderness, they found that land cut back by around 5 feet 10 inches a year. Since Roman times, Holderness had retreated 3½ miles, losing 73,780 acres of land (115 square miles) and 3.052 million tons of cliff. Sheppard discusses in some detail the lost towns of the Humber – an interesting read but beyond the scope of this account. However, he goes on to describe twenty to thirty settlements documented but known to have been destroyed during historic times. Clearly, we could add to the list numerous farmsteads, hamlets and smaller or older settlements all long since swallowed up by the sea. Gordon Ostler also provides an excellent account of *Coastal Erosion and the Lost Towns of Holderness*, stating,

> I believe that there are very severe consequences for the people of Holderness arising from the erosion that is happening on the East Coast. Major towns and cities, for example Beverley and Hull, will be washed away as will some of the best farmland in the country.

Coastal erosion of the cliffs at Easington, 1930s.

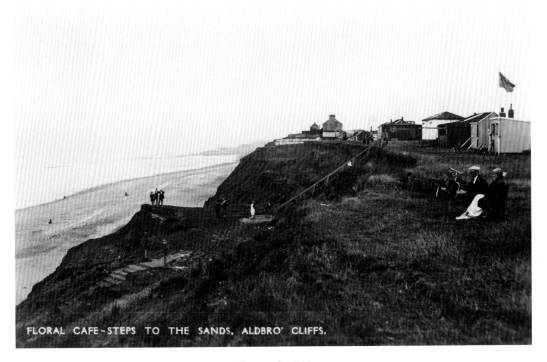

Floral Café and steps to the sands at Aldborough, 1920s.

Various estimates have made for land lost to the sea over the centuries of erosion, the distance of the coastline in Roman times from that today often suggested as around 3 1/2 miles (calculated by Ernest Matthews, civil engineer, in 1905). The slumping of the cliffs and the washing away of the material by the sea has been going on from when the boulder clay was first deposited. Calculations indicate that since the Romans occupation, a belt of land around 3 ½ miles wide along the Holderness Coast has washed into the North Sea. George de Boer (1964) estimated that 2 miles of coast have been lost since the Norman invasion in 1066. Without major engineering intervention, the North Sea will cut the Holderness shoreline all the way to the Yorkshire Wolds chalk cliff.

Why So Erodible?

Around 2 million years ago, what is now East Yorkshire had a coastline formed by a chalk cliff along the eastern edge of the Yorkshire Wolds. This extended from Flamborough to Beverley and Hessle, and Holderness was a shallow bay. Then a major Ice Age glaciation occurred dumping two 'tills' (boulder clays): Withernsea Till and Skipsea Till across the low-lying ground. When the ice retreated 10–15,000 years ago, it left behind these soft boulder clays made of fine silts, boulders (hence the name), gravel, and fossils. The resulting clay cliffs are extremely unstable with slumping caused by rain and sea. When wet the clay is slippery like butter, which allows it to flow. As the cliffs slump on to the beach, the sea washes away the clay to leave 'erratics', or boulders carried huge distances by the ice.

However, as Yorkshire shrinks, not all the material is washed out to sea, some being redeposited on the Lincolnshire coast and some onto Spurn. The Spurn headland has fluctuated over the centuries, at times an island and at times an eroding sandspit; presently eroding it will eventually breach with the tip once more, forming an island. George de Boer (1964) suggested Spurn had a 250-year cycle, with each episode moving further west.

Along the present-day Holderness coast, only about 16 per cent has sea defences. What's more, where defences occur they interrupt the movement longshore of sands and gravels, which form the beaches. Waves breaking on the shore move materials such as sand, shingle, cobbles, and rocks along the coast through a process called 'longshore drift'. Here lies the twist for the Holderness coast, since if movement of materials is interrupted by natural topography or constructed feature like groynes or seawalls, then deposition of sediment reduces. This means that while major defence works protect individual sections of shoreline, they cut off beach-forming materials and may trigger increased erosion further down the coast. Sediments are carried out to sea, which reduces beach levels and means waves break on the cliff-bases with increased destructive effects.

Soon after costal defences are constructed, sections of clay cliff immediately on the downdrift side of the works start eroding more quickly. Indeed, the effect can be sudden and dramatic, producing a typically crenulate or notched shape. This process may extend a distance down the coast, and can creep behind constructed defences. Usually, the situation will move back into a more stable condition where the erosion rate is back to the same as the rest of the shoreline, though the eroded 'notch' or crenulation will remain like a giant bite out of the coastline. This phenomenon is also called the 'terminal groyne effect' and is observable beyond the last groyne of a series of coastal defences.

The Lost Towns & Villages

In 1889, J. R. Boyle wrote *Lost Towns of the Humber*, which notes how Burstall Priory at Skeffling was lost to the sea; in ruins by the 1700s, it finally disappeared in floods during the early 1900s. Elderly local people in the late twentieth century could still recall seeing it out on the mudflats. Numerous villages were lost from the north shore of the Humber, but

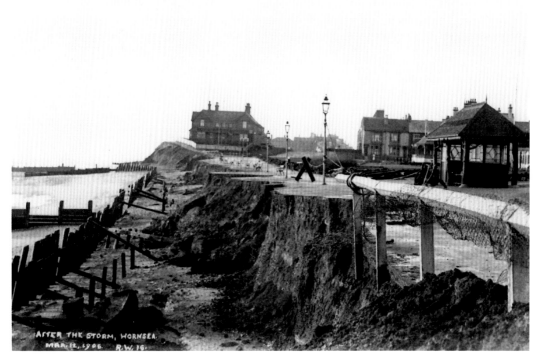

Hornsea seafront after the great storm on 12 March 1906.

many others have disappeared from the Holderness coast itself: Hoton, Old Withernsea, Old Kilnsea, Out Newton, Northorp, Dimlington, Turmarr and Sunthorpe. We know many of these from the extensive records held by the monastic landowners. Much information on the lost settlements is from the writings Abbot (AD 1393–99) of Meaux Abbey in East Yorkshire. Burton's *Chronica Monasterii de Melsa* names lost villages, towns and hamlets. Other sources include the Icelandic Sagas telling, for example, the story of Harald Sigurdson (Hardrada) who sailed from Hrafnreyri (Ravenser).

Some settlements known to be lost include Frismersk, where flooding began in the 1300s, with 321 acres of arable, 100 acres of meadow, and 152 acres of pasture destroyed; Orwithfleet, totally destroyed between 1310 and 1339; East Somerte, lost very early; Tharlesthorpe, which was given up to the sea by the early 1400s despite considerable coastal defence works; Penysthorpe, destroyed; Sunthorpe, destroyed. Those living in these settlements probably just dispersed to other villages nearby.

Kilnsea: Between 1822 and 1852, around twenty-four houses and the church, plus associated buildings, were all washed away. The erosion rate was 5 yards per year between 1766 and 1833, rising to 3.3 yards per year from 1876 to 1881. The Blue Bell Inn at Kilnsea, built in 1847 at a distance of 534 yards from the cliff, was only 272 yards away by 1910.

Skipsea Withow Mere: This was once one of numerous post-glacial small lakes or meres across Holderness and probably one of the larger ones. Hornsea Mere still exists, and Skipsea Mere survived, though modified, being drained around 1720. The reclaimed land

was allotted to those responsible. Withow at Skipea was destroyed by erosion around 400 years ago, but the peat sediments can still be seen in the low cliffs and are a scheduled Site of Special Scientific Interest (SSSI). The lower peats have been dated as about 10,000 years old at and the upper ones as 4,500 years.

Ringbrough, or Ringborough (*Ringheborg* Domesday): This little-known settlement was lost to the sea, and just a single farm was all that remained by the early nineteenth century. During the Second World War, the farm was used as an artillery battery, but today all the wartime site with brick-built observation tower and gun emplacements have disappeared. Built in the 1770s, in 1833 located 305 yards (279 metres) from the cliff, the farm buildings were finally demolished just a few years ago.

Great Colden, Great Cowden (*Coledun* Domesday): Running north-south with fields to either side was a relatively recent loss to the sea on the Holderness coast. By the mid-1800s, the cliff was around 150 metres from the north end of the main street, and in subsequent decades, the community migrated east as the shore eroded. The lane to Great Colden from the Hornsea to Aldbrough road now terminates in bollards and a pile of soil, its destination now lost at sea. The modern Great Cowden has a replacement Cross Keys public house (later the Blue Boar) at the end of Eelmere Lane.

Easington: This location gained a major North Sea gas terminal in March 1967 but it was expected that the useful life of the site would be long over before erosion became problematic. However, gas reserves proved greater than originally expected and in 1999, a kilometre-long coastal defence was constructed with over 130,000 tons of rock. The design had to accommodate the two Sites of Special Scientific Interest (Dimlington High Land and Easington lagoons) located close by.

Hornsea South: In the 1800s, as Hornsea grew rapidly as a seaside town, the issues of coastal erosion became very apparent. The first major sea defence was built in 1870, but lasted only six years and the resulting acceleration in erosion of areas adjacent was noted. Then, in 1906, a stronger seawall was built; so far, this has been extended and enhanced a further five times. In 1977, to address issues of accelerated erosion and 'outflanking' of the defences at the southern end of the town, the defences were redesigned. Constructing a limb jutting out perpendicular to the cliff holds sediment beyond the seawall and building a new extension parallel to the cliff helps reduce outflanking. At the same time as protecting the shore, beach sediment is allowed to accumulate and to move behind the defences.

Mappleton: This village is on the B1242 coastal road close to the cliff line, and by the early eighteenth century it was clear that the sea was cutting in on the settlement. In 1786, the church was 630 yards (576 metres) from the clifftop, which reduced to 223 metres by 1990 – an average loss of 1.73 metres per year. In 1991, in order to protect the village and the road, a substantial sea defence was constructed, costing £2 million and similar to that in south Hornsea.

Ulrome & Skipsea: This stretch of coastline is problematic and lacks any major intervention, so from the early 1990s, the seawall at Ulrome beach was constructed privately and is maintained independently. Additionally, a so-called 'plug revetment' was added to defend a single property approximately 200 metres south of Skipsea. Crenulate embayment is cutting into the coast here and the southern Ulrome defences have been damaged repeatedly. At Skipsea itself, the original coastal revetment is fragmenting.

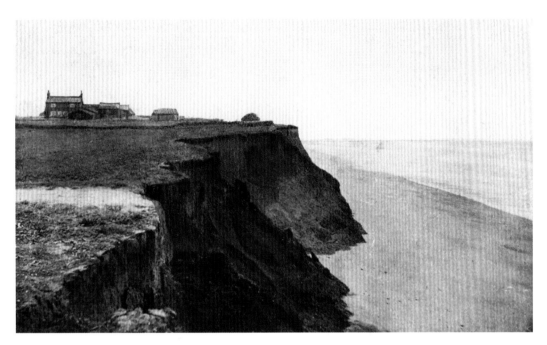

The eroding cliffs at Skipsea, early 1900s.

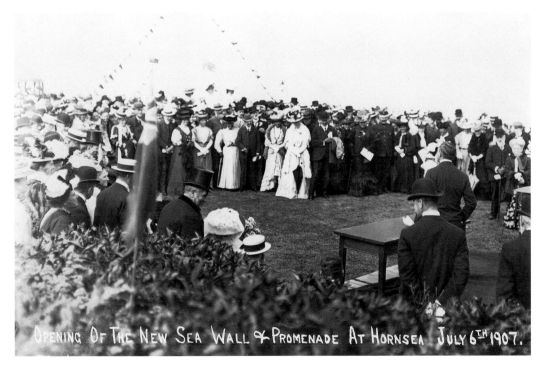

Opening of the new sea wall at Hornsea on 6 July 1907.

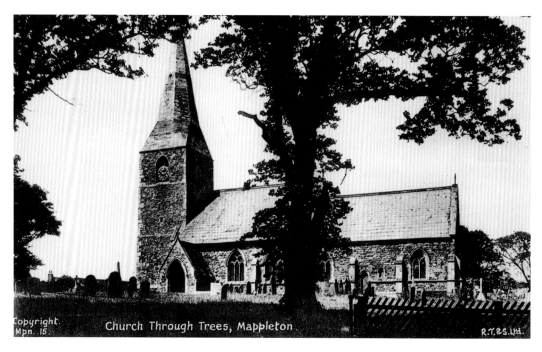

Mappleton church, mid-twentieth century.

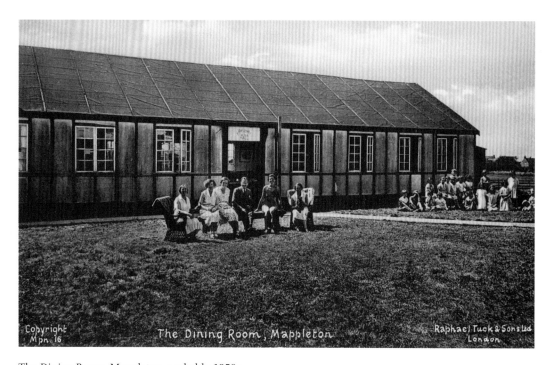

The Dining Room, Mappleton, probably 1950s.

The beach and sands with crumbling cliffs and Second World War concrete defences at Ulrome near Skipsea, posted in 1972.

The Cottage, Ulrome, 1920s.

Withernsea South: To defend this major settlement, during the 1870s there are significant defences built at Withernsea, and these have been added to around nine times so far. In 1968, rock armour was added to defend properties south-west of the earlier sea wall. More was added in 2005, but increased erosion has been triggered beyond the most recent work with resulting crenulate embayment. There are earlier embayments seen behind the sea defences. Part of the Golden Sands Holiday Park is located by the eroding cliff.

Ravenser: This tiny settlement was at the extreme southern end of the eroding coast. It seems that, following the failed Viking invasion of 1066, Ravenser remained just a modest hamlet. According to Home (1908), it was not heard of again for nearly two centuries, and then only in connection with the new Ravenser, which had grown on a spit of land gradually, thrown up by the tide within the spoon-shaped ridge of Spurn Head.

> On this new ground a vessel was wrecked some time in the early part of the thirteenth century, and a certain man—the earliest recorded Peggotty—converted it into a house, and even made it a tavern, where he sold food and drink to mariners. Then three or four houses were built near the adapted hull, and following this a small port was created, its development being fostered by William de Fortibus, Earl of Albemarl, the lord of the manor, with such success that, by the year 1274, the place had grown to be of some importance, and a serious trade rival to Grimsby on the Lincolnshire coast. To distinguish the two Ravensers the new place, which was almost on an island, being only connected with the mainland by a bank composed of large yellow boulders and sand, was called Ravenser Odd, and in the Chronicles of Meaux Abbey and other records the name is generally written Ravenserodd. The original place was about a mile away, and no longer on the shore, and it is distinguished from the prosperous port as Ald Ravenser. Owing, however, to its insignificance in comparison to Ravenserodd, the busy port, it is often merely referred to as Ravenser, spelt with many variations.
>
> Gordon Home, *Yorkshire* (1908)

Rivalry with Grimsby or Sheer Piracy?

Ravenser grew rapidly and was successful, though its business was not exactly legitimate, as explained by Home (1908):

> The extraordinarily rapid rise of Ravenserodd seems to have been due to a remarkable keenness for business on the part of its citizens, amounting, in the opinion of the Grimsby traders, to sharp practice. For, being just within Spurn Head, the men of Ravenserodd would go out to incoming vessels bound for Grimsby, and induce them to sell their cargoes in Ravenserodd by all sorts of specious arguments, misquoting the prices paid in the rival town. If their arguments failed, they would force the ships to enter their harbour and trade with them, whether they liked it or not. All this came out in the hearing of an action brought by the town of Grimsby against Ravenserodd. Although the plaintiffs seem to have made a very good case, the decision of the Court was given in favour of the defendants, as it had not been shown that any of their proceedings had broken the King's peace.

However, it is clear that no matter how enterprising or ruthless the men of Ravenser were, they were living on borrowed time. Moreover, Gordon Home (1908) explains the ultimate demise of a village built on sand.

The story of the disaster, which appears to have happened between 1340 and 1350, is told by the monkish compiler of the Chronicles of Meaux. Translated from the original Latin the account is headed: 'Concerning the consumption of the town of Ravensere Odd and concerning the effort towards the diminution of the tax of the church of Esyngton.

But in those days, the whole town of Ravensere Odd ... was totally annihilated by the floods of the Humber and the inundations of the great sea ... and when that town of Ravensere Odd, in which we had half an acre of land built upon, and also the chapel of that town, pertaining to the said church of Esyngton, were exposed to demolition during the few preceding years, those floods and inundations of the sea, within a year before the destruction of that town, increasing in their accustomed way without limit fifteen fold, announcing the swallowing up of the said town, and sometimes exceeding beyond measure the height of the town, and surrounding it like a wall on every side, threatened the final destruction of that town. And so, with this terrible vision of waters seen on every side, the enclosed persons, with the reliques, crosses, and other ecclesiastical ornaments, which remained secretly in their possession and accompanied by the viaticum of the body of Christ in the hands of the priest, flocking together, mournfully imploring grace, warded off at that time their destruction. And afterwards, daily removing thence with their possession, they left that town totally without defence, to be shortly swallowed up, which, with a short intervening period of time by those merciless tempestuous floods, was irreparably destroyed.

Following the disaster, the local traders and inhabitants generally moved to Hull and other nearby towns, less prone to the ravages of the sea.

A Disappearing Coast

The story of the eroding shore of Holderness is of major engineering works to protect a few, selected townships or installations, but set against a never-ending, intractable incursion by the erosive power of the sea. History is a great informer, and here the lesson is of unending, one-way loss. The heavy sea defences make conditions beyond them more acute and so they are outflanked and outgunned by the waves. Where will it end? With nothing done to halt the retreat, the defended sites like Hornsea and Withernsea will stand proud at the end of long promontories and the sea will cut through to the hard rock beyond Beverley. Furthermore, with sea level rise and increased storm events, the process will accelerate.

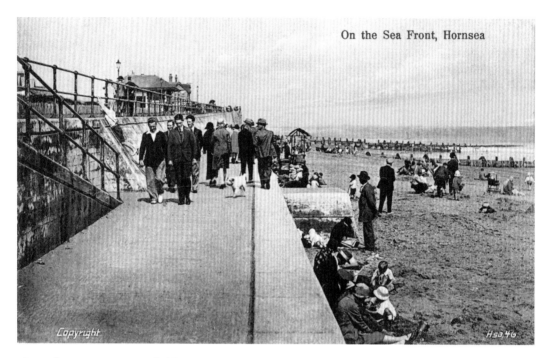

The seafront at Hornsea, probably 1930s.

Just a line from Hornsea to Mr Brown of Spencer Street in Cleethorpes in 1909.

A Remarkable Heritage – Some of the Main Sites & Places

This final chapter introduces and illustrates some of the main houses, halls, parks, estates, nature reserves, churches and other locations across the region. The coastal belt offers tremendous seaside walking from spectacular clifftops to the lower-lying beaches, sand dunes and cliffs of Holderness. Small and modest seaside resorts dot the coastline and inland, the typical East Yorkshire villages and hamlets present an understated charm with ancient churches, archaeological sites and a few stately homes. There are numerous caravan and camping sites from quite small to very large, and a tendency nowadays for these to move somewhat more upmarket than in the past.

Daniel Defoe, writing in the 1700s, was less than impressed by the Holderness coast: '...the most that I find remarkable here is that there is nothing remarkable . . . for above thirty miles together; not a port, not a gentleman's seat, not a town of note.'

Bempton Cliffs RSPB Nature Reserve: An RSPB Nature Reserve since the 1970s, Bempton has become very popular in recent decades and the RSPB has invested heavily in the facilities and support for visitors. Furthermore, today the adjacent farmland has been managed to improve wildlife and landscape aesthetics and a long-distance clifftop walk connects the site to others nearby.

Flamborough Head & the coastal path: Immediately south of Bempton lies the spectacular headland of Flamborough with its ancient and modern lighthouses, a cluster of cafés, car parking and other facilities. This is a fantastic place to sit and watch the sea, the boats and the seabirds or seals.

Danes Dyke Local Nature Reserve: This prehistoric boundary marker is a major feature running across the headland and is a natural structure enhanced for strategic purposes. The Victorians 'improved' parts of the site as a recreational romantic walk, and it is managed today as a small country park. With sheltered woods and a range of wildlife not found on the exposed cliffs, the dyke makes a pleasant contrast to the adjacent sites. For the birdwatcher too, the dyke can be attractive to migrant birds such as rare warblers seeking shelter from the coastal weather on more exposed sites.

Sewerby Hall: Sewerby Hall (Sewerby House) is a Grade I listed Georgian country house in 50 acres (20 hectares) of landscaped gardens in the village of Sewerby. The hall is 2 miles (3.2 km) north of Bridlington. Today, Sewerby Hall is a major tourist attraction with over 150,000 visitors annually. The hall houses the Coastguard Museum and the Museum of East Yorkshire, with a room dedicated to locally born aviator, Amy Johnson. The grounds of the hall include a small zoo and aviary, plus an 18-hole putting range and a variety of gardens. The site hosts local community events and is a venue for tourism activities too.

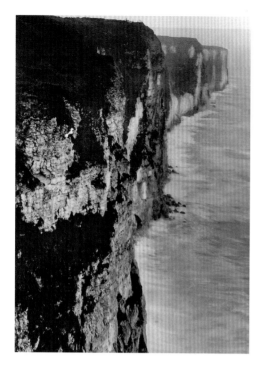

Speeton or Bempton Cliffs, Filey, around the 1940s.

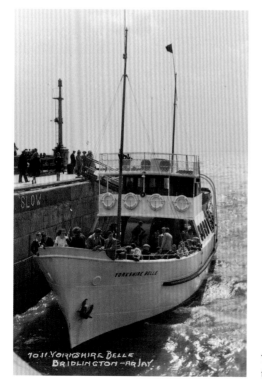

The *Yorkshire Belle* taking on sightseers to view the cliffs and wildife at Flamborough, 1960s.

Information from: Sewerby Hall and Gardens, Church Lane, Sewerby, Bridlington, East Riding of Yorkshire, YO15 1EA. Telephone: (01262) 673769; fax: (01262) 673090; email: sewerby.hall@eastriding.gov.uk.

Bridlington, Bridlington Harbour, Old Burlington, Bridlington Priory: This popular seaside town offers much to be discovered at the seafront and the harbour but inland around the historic priory church too. If you think you know Bridlington, then look again.

Burton Agnes Hall: Built between 1598 and 1610 by Sir Henry Griffith, Burton Agnes Hall is an Elizabethan stately home held by a single family for over 400 years. Fifteen generations filled the hall with treasures, from magnificent carvings commissioned when the hall was built, to French Impressionist paintings, contemporary furniture, tapestries and contemporary artwork. Simon Jenkins, in *England's Thousand Best Houses*, described Burton Agnes Hall as 'the perfect English house' and, alongside Windsor Castle, Buckingham Palace and Chatsworth House, one of the twenty best English houses. Information from: The Estate Office, Burton Agnes Hall, Burton Agnes, Driffield, East Yorkshire, YO25 4NB. Telephone (Estate Office): 01262 490324; email: office@burtonagnes.com; www.burtonagnes.com.

Barmston beach & dunes: The beach here makes for a pleasant seaside walk, with a variety of birds on marshes to the landward side and typical coastal birds along the water's edge, depending on tides and seasons. In winter, watch for Lapland buntings and even shorelarks along the tidelines, where they mix with goldfinches and perhaps twite. At the water's edge, dunlin and the tiny sanderlings dart at the mobile interface of land and water.

Skipsea beach & castle: Skipsea Castle and its mere are well worth a visit and the coastline offers easy beach walking.

Hornsea & Hornsea Mere: There are facilities around the quay and the moorings for the boat-club, and nice walks on footpaths around sections of the mere. This is a good place to watch wildlife.

Wassand Hall & Gardens: Wassand Hall is a fine Regency House in beautiful tranquil surroundings between Seaton and Hornsea on the B1244, approximately 12 miles east of Beverley, 18 miles north of Hull. The estate has been in one family's ownership since 1530 and enjoys beautiful walled gardens, woodland walk and half-mile park walk with views of Hornsea Mere, which belongs to the estate. Information from: Wassand Hall & Gardens, Seaton, Hornsea, HU11 5RJ; telephone: 01964 534488; www.wassand.co.uk.

Withernsea: With a mix of a good beach and typical seaside resort attractions, Withernsea offers much to the holidaymaker and there is a good range of camp and caravan sites and other accommodation.

Spurn Head & Lighthouse: Spurn has a diverse range of features of natural history and historical significance, and with new investment is becoming more attractive to the general visitor rather than just the diehard birder.

Hull: Hull has a vibrant tradition of arts and culture with several museums of national importance. The city has a strong theatrical tradition with some famous actors and writers having been born and living there. Hull has diverse architecture complemented by parks and squares, statues and modern sculptures.

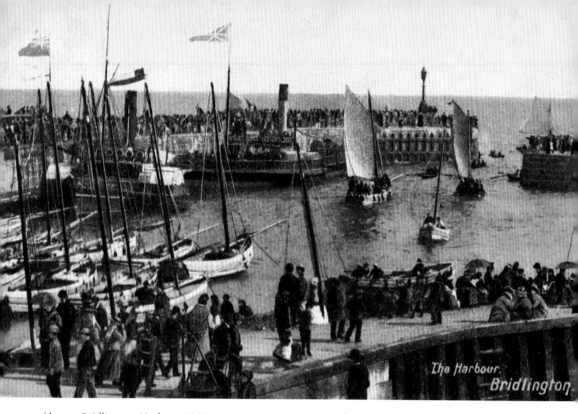

Above: Bridlington Harbour, 1906.

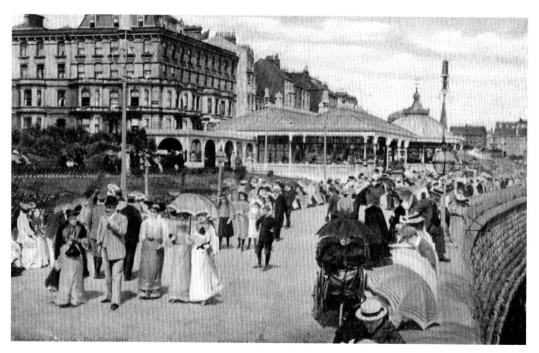

Princes Parade, Bridlington, 1906.

Edwardian family on the beach near Hornsea.

Storm over Spurn, 1970s.

Hull Museums: Hull's Museum Quarter in the Old Town High Street includes Wilberforce House, the Arctic Corsair, the Hull and East Riding Museum (with the Hasholme Logboat – Britain's largest surviving prehistoric logboat), and the Streetlife Museum of Transport. Other museums and visitor attractions include the Ferens Art Gallery with a good range of art and regular exhibitions, the Maritime Museum in Victoria Square, the Spurn Lightship, the Yorkshire Water Museum, and The Deep public aquarium. The Seven Seas Fish Trail marks Hull's fishing heritage through old and new sections of the city.

Hull Theatres: The city has two main theatres, Hull New Theatre (opened 1939) and a major venue for musicals, opera, ballet, drama, children's shows and pantomime, and The Hull Truck Theatre (smaller independent theatre established 1971).

Mick McMichael (left) and Steve Clements

THE YORKSHIRE TERRIERS

The Yorkshire Terriers all-in wrestling team as they appeared at Hornsea in the 1960s.

Bibliography – Sources & Suggested Reading

Abbot Burton, *Chronica Monasterii de Melsa* (1369–99).

Andrews, W. (ed.), *Bygone Yorkshire* (A. Brown & Sons, Hull & York, 1892).

Anon., *A Guide to all the Watering and Sea Bathing Places* (Longman, Rees, Orme, Brown & Green, London, 1842).

Anon., Bridlington Quay. *The Illustrated London News*, 20 October, p. 268 (1849).

Anon., 'The Flamborough Head Cliff-climbers', *The Sketch*, 20 July, p. 27 (1896).

Anon., *Bridlington Memories* (Bayle Museum Trust, Bridlington, 1995).

Anon., *Victoria County History: A History of the County of York East Riding: Volume 7: Holderness Wapentake, Middle and North Divisions: North Division: Skipsea* (Victoria County History, London, 2002).

Anon., *Bridlington Priory. The Parish Church of St. Mary. A Pictorial Guide* (The Stuart Burns Design Studio, Beeford, East Yorkshire, undated).

Barker, M., *The Golden Age of the Yorkshire Seaside* (Great Northern Books, Ilkey, 2002).

Beresford, M., *New Towns of the Middle Ages: Town Plantation in England, Wales and Gascony* (Lutterworth Press, London, 1967).

Boyes, M. & Chester, H., *Walks from Your Car. Bridlington and Scarborough* (Dalesman Books, Clapham, Lancs, 1991).

Boyle, J. R., *Lost Towns of the Humber* (A. Brown & Sons, Hull, 1889).

Brealey, F., *A History of Flamborough* (The Ridings Publishing Co., Driffield, 1971).

Broadhead, I. E., *Portrait of Humberside* (Robert Hale, London, 1983).

Butler, R., 'Skipsea Brough', *Archaeological Journal*, 141, pp. 45–6 (1984).

Cape, T., *Brief sketches descriptive of Bridlington Quay and the Most Striking Objects of Interest in the Neighbourhood Intended Chiefly for Visitors* (G. Furby, Bridlington-Quay, 1868).

Chapman, V., *Yorkshire Seaside Resorts and Harbours in Old Picture Postcards* (European Library, The Netherlands, 1997).

de Boer, G., 'Spurn Head: Its History and Evolution', *Trans. Inst. Br. Geog.* 34, pp. 71–89 (1964).

Defoe, D., *Tour Through the Eastern Counties of England* (1722).

Dickens, A. G., *The East Riding of Yorkshire with Hull and York. A Portrait* (A. Brown & Sons Ltd, London & Hull, 1954).

Dykes, J., *Smuggling on the Yorkshire Coast* (The Dalesman Publishing Co. Ltd, Clapham, Lancs, 1978).

Ellis, S. & Crowther, D. R. (eds), *Humber Perspectives: A Region Through the Ages* (Hull University Press, Hull, 1990).

Ellison, N., *Roving With Nomad* (University of London Press Ltd, London, 1949).

English, B., *The Lords of Holderness 1086–1260* (Hull University Press, Hull, 1991).

English, B., *Ravenser Odd, A Lost East Yorkshire Town.* Chapter 10 in Lewis, D. B. (ed.), *The Yorkshire Coast*, Normandy Press, pp. 149–155 (1991).

Fairfax-Blake, J. & Fairfax-Blake, R., *The Spirit of Yorkshire* (B. T. Batsford Ltd, London, 1954).

Fletcher, J. S., *Nooks & Corners of Yorkshire* (Eveleigh Nash, London, 1910).

Francillon, R.E., 'A Mysterious Monument: The Monolith in Rudston Churchyard, Yorkshire', *The Graphic*, 18 April, p. 566 (1908).

Frank, G. F., 'The Yorkshire coast by an Old Shellback', *The Yorkshire Herald*, 15 July 1899, *The Evening Post*, 5 June 1910, and the *Scarborough Mercury,* 15 July 1927 (1899).

Gelsthorpe, J., *The Royal Naval Air Service at Hornsea Mere and Killingholme 1914–1919* (Lodge Books, Bridlington, 2014).

Gerrard, D. (ed.), *The Hidden Places of Yorkshire Including the Yorkshire Dales* (Travel Publishing Ltd., Aldermaston, Berks).

Gillett, E. & MacMahon, K. A., *A History of Hull* (Hull University Press, Hull, 1989).

Gough, S. W., *The Yorkshire Coast.* The England That I Love, No. 1 (undated).

Hammond, R. J. W. (ed.), *The Yorkshire Coast* (third edition, Ward, Lock & Co. Ltd, London and Melbourne, 1966).

Hartley, K. E., 'The Spurn Head Railway', *Industrial Railway Record*, 67, pp. 249–292 (1976).

Hatcher, J., *Exploring England's Heritage. Yorkshire to Humberside* (English Heritage, HMSO, London, 1994).

Hemingway, J. E., Wilson, V. & Wright, C. W., *No. 34: Geology of the Yorkshire Coast* (Benham & Co. Ltd, Colchester, 1968).

Home, G., *Yorkshire* (Black, London, 1908).

Jones, N. V. (ed.), *A Dynamic Estuary: Man, Nature and the Humber* (Hull University Press, Hull, 1988).

Laughton, T., *Royal Hotel. The Story of a Family Enterprise* (Royal Hotel, Scarborough, 1967).

Leyland, J., *The Yorkshire Coast and the Cleveland Hills and Dales* (Seeley & Co. Ltd, London, 1892).

Limon, M., *The Villages of East Yorkshire* (Blackthorn Press, Pickering, 2010).

Markham, L., *Clarty Strands. A Walking Tour of the Yorkshire Coast* (Hutton Press Ltd, Beverley, 1990).

Markham, L., *Discovering Yorkshire's History* (Wharncliffe Books, Barnsley, 2004).

Mather, J. R., *Where to Watch Birds in Yorkshire and North Humberside* (Christopher Helm, A. & C. Black, London, 1994).

Matthews, E. R., Coast Erosion and Protection. No. II. *Engineering*, 20 September, 380–382 (1912).

Neave, D., *Port, Resort and Market Town. A History of Bridlington* (Hull Academic Press, Hull, 2000).

Neave, D. & Turnbull, D., *Landscaped Parks and Gardens of East Yorkshire* (Georgian Society for East Yorkshire, Hull, 1992).

Ostler, G., 'Coastal Erosion and the Lost Towns of Holderness', *Humberside Geologist*, 14, pp. 98–100 (2006).

Pounds, N. J. G., *The Medieval Castle in England and Wales: A Social and Political History* (Cambridge University Press, Cambridge, 1990).

Renn, D., *The Norman Castle in Britain* (John Baker, London, 1968).

Robinson, R., *A History of the Yorkshire Coast Fishing Industry 1780–1914.* (Hull University Press, Hull, 1987).

Rotherham, I. D., *Yorkshire's Forgotten Fenlands* (Pen & Sword Books Ltd, Barnsley, 2010).

Rotherham, I. D., *Yorkshire's Dinosaur Coast.* (Amberley Publishing, Stroud, 2014).

Rowley, J. C., *The Hull Whale Fishery* (Lockington Publishing Company, Newton Abbot, 1982). Sheppard, J. 'The Medieval Meres of Holderness', *Transactions of the Institute of British Geographers*, XXII, 75–86 (1957).

Sheppard, J., 'The Draining of the Hull Valley', *East Yorkshire Local History Series*, 8 (East Yorkshire Local History Society, Beverley, 1958).

Sheppard, J., 'The Draining of the Marshlands of South Holderness and the Vale of York', *East Yorkshire Local History Series*, 20 (East Yorkshire Local History Society, Beverley, 1966).

Sheppard, T., *The Lost Towns of the Yorkshire Coast and Other Chapters Bearing Upon the Geography of the District* (A. Brown & Sons, Hull & York, 1912).

Simmons, G., *East Riding Airfields 1915–1920* (Crécy Publishing Ltd, Manchester, 2009).

Smith, G., *Smuggling in Yorkshire 1700–1850* (Countryside Books, Newbury, Berks, 1994).

Smith, M. H. (ed.), *Hornsea A Century Ago. The Town and its People in the 1890s* (Hornsea Local History Class, Highgate Publications Beverley Ltd, Beverley, 1993).

Southwell, G. L., *Hornsea in Old Picture Postcards* (European Library, Netherlands, 1983).

Sumner, I. & Sumner, M., *Britain in Old Photographs: Bridlington* (Alan Sutton Publishing Ltd, Stroud, 1995).

Vaughan, R., *Seabird City. A Guide to the Breeding Seabirds of the Flamborough Headlands* (Smith Settle, Otley, 1998).

Walcott, M. E. C., *Guide to the Coasts of Lincolnshire & Yorkshire* (Edward Stanford, London, 1861).

Walker, G., *The Costume of Yorkshire.* (Longman, Hurst, Orme and Brown, London, 1814).

Whitaker, J. (ed.) *A Diary of Bempton Climbers* (Peregrine Books, Leeds, 1997).

Whitworth, A. (ed.), *Aspects of the Yorkshire Coast. Discovering Local History* (Wharncliffe Publishing, Barnsley, 1999).

Whitworth, A. (ed.), *Aspects of the Yorkshire Coast. Discovering Local History 2* (Wharncliffe Publishing, Barnsley, 2000).

Williamson, P., *Castle Walks in Yorkshire* (Palatine Books, Lancaster, 2006).

Wilson, C., *Flamborough Through the Ages. A Look at the History of the Headland and its People* (The Heritage Coast Project, Flamborough, undated).

Woodward, D. (ed.), 'Descriptions of East Yorkshire: Leland to Defoe', *East Yorkshire Local History Series*, 39, East Yorkshire Local History Society, Beverley (1985).

Leaving Bridlington on 11 July 1910.

A carriage trip to Withernsea, late 1800s or early 1900s.

The windmill at Hornsea, around 1906.

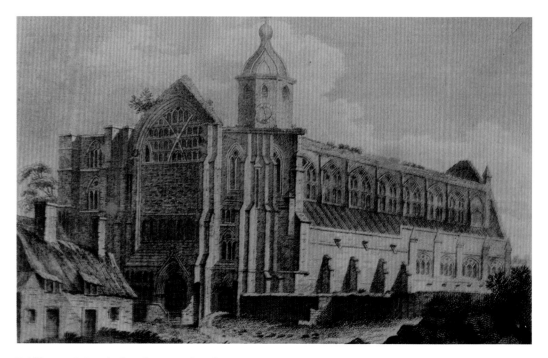

Bridlington Priory before the great demolition.